ENSOR

ENSOR

Roger Van Gindertael

translated from French by
Vivienne Menkes

New York Graphic Society
Boston

International Standard Book Number: 0-8212-0649-4
Library of Congress Catalog Card Number: 74-21493

Published in 1975 in French by Alfieri & Lacroix
First published in English by Studio Vista
35 Red Lion Square, London WC1R 4SG
First published in 1975 in the United States by
New York Graphic Society Ltd.
11 Beacon Street, Boston, Massachusetts 02108

Printed in Italy

Contents

1 Ensor seen in profile

overleaf 2 Ensor painting in his studio-cum-living-room

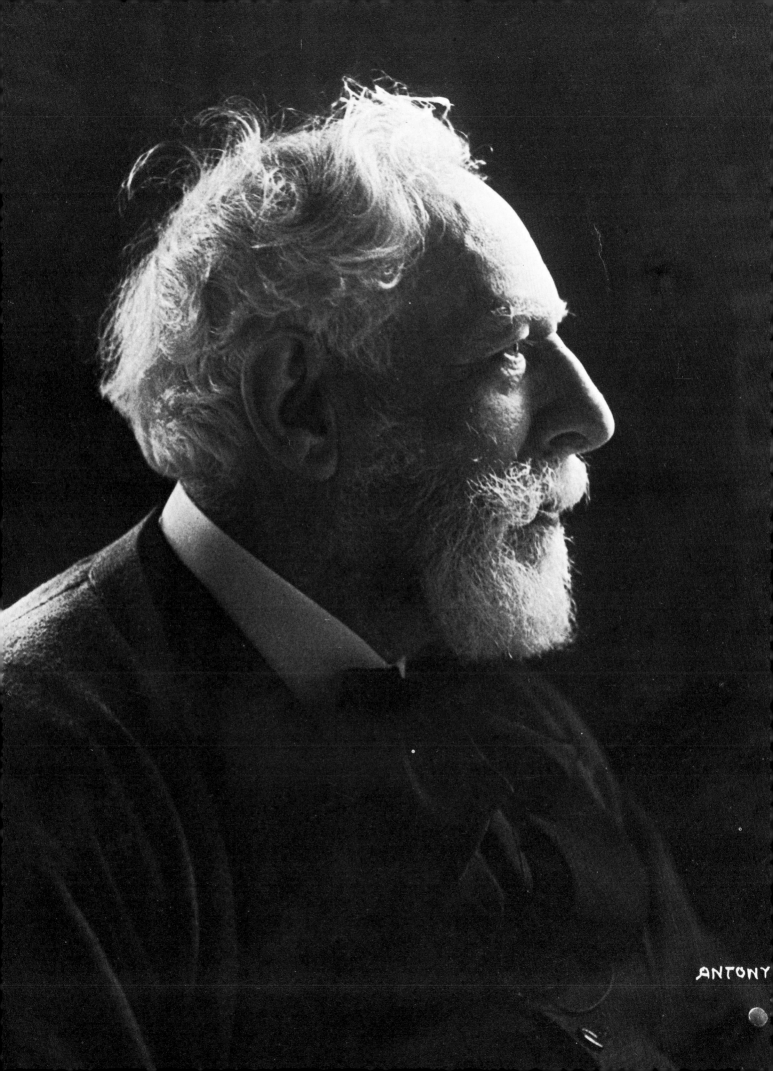

ANTONY

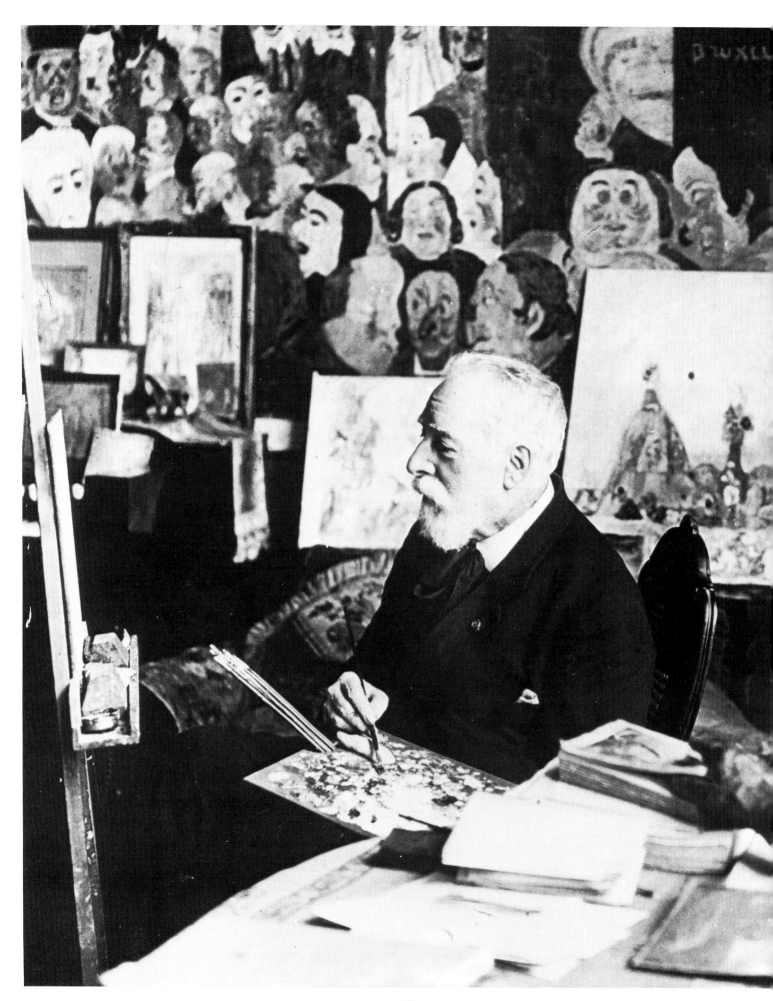

Preface

James Ensor is universally recognized as one of the most
original figures in modern painting, indeed one of the most
original artists of all time. He was also a precursor of various
innovatory movements that have emerged during the
twentieth century.

A large number of retrospective exhibitions of his work
have been held and he has also been included in a good
many of the most important group exhibitions of
contemporary art — particularly of course those devoted
to Belgian artists. He is referred to in all books on art
history, and a number of books and articles have been
devoted to him. It might be reasonable, therefore, to assume
that both the man and his work are well known and that
his position within the context of his own age has been
clearly defined. Yet the fact is that opinions about various
aspects of his work, and attempts to correlate it with the
artistic events that occurred in his lifetime, may have been
falsified by inexplicit references or deductions based on
inaccurate or imprecise data. What is more, it is quite
possible that Ensor himself was partly responsible for some
errors in interpretation concerning the circumstances in which
he executed his paintings and graphic work, their individual
characteristics, their meaning and their range.

The exceptionally long life of this majestic white-haired
figure, whose black-garbed silhouette haunted the breakwater
at Ostend for more than fifty years, probably made people
forget at times that all the work on which his fame rests,
and which incidentally still seems surprisingly modern, in fact
dates back to the nineteenth century. It is important that
we should think of his work in the context of that period and
judge it accordingly. Yet even his most intelligent and
fervent admirers have not always taken this historical
situation into account, seeing him as an avant-garde artist
whose innovatory impetus is still having an effect today.
This exaggeration has tended to harm his reputation rather
than to convince his critics.

Ensor himself always refused, right to the day of his death,
to take his place among the veterans. Even when he had
reached a great age, he would still exclaim: 'Let us go
forward together, all of us young people!' When I compiled
a short anthology of young Belgian painters in 1925 I felt
that it would be impertinent to include a reproduction of a

11

painting by this elderly master. I learnt subsequently, however, that he had been extremely upset to find that he had been left out. To refuse to grow old and to side with younger generations are characteristics that are both natural and generous in an artist. But his assertions that he had foreseen and anticipated all later schools of art may seem somewhat exaggerated and naïve. He claimed, for instance, that he had written the word 'Futurist' on some of his drawings dating from 1885, but in fact this was not added until later. He was still more vehement when he stated in his writings: 'When I flick through the sketches I did in 1877 I find Cubist angles, Futurist brilliance, Impressionist flakes, Dada horsemen and Constructivist appendages.'

Although we may forgive him for such statements, it is a pity that some of his disciples have insisted that he had foreknowledge of most of the forms of expression used by later artists, even if he didn't actually discover them. They are neglecting the essential point, which is that the bold and unusual quality of Ensor's work is more important for the effect it had on the work of his contemporaries than for any influence it may have exerted subsequently.

I don't think that an attempt to demystify Ensor's legend — a legend that he created for himself and upheld with malicious glee — would cast a slur on the integrity and splendour of his genius. In fact I am convinced that a study of the true facts and an objective examination of his subversive attitude and his originality in the historical, aesthetic, ideological and social context of his age is the best way of illuminating the meaning underlying his work. In this way we can emphasize his exceptional qualities and reveal the true greatness of the 'enigmatic and lonely genius of Ostend', as Paul Haesaerts describes him in his book *Histoire de la Peinture Moderne en Flandre*.

A work of art can best be defined and illuminated in relation to the circumstances surrounding its execution. In the case of Ensor, even though he may have been an 'indomitable genius', we cannot hope to reach a fuller understanding and a fairer and more accurate assessment of his work unless we try to set him in the context of his *milieu* and of his age. So in this book I have deliberately set out simply to gather together a series of notes, observations, quotations and documentary material loosely linked to a biographical essay and a discussion of his most important or most characteristic paintings or drawings. The main aim of the book is to offer the reader an opportunity to take a fresh look at Ensor's work.

Childhood in Ostend

James Ensor was born in Ostend on Friday, 13 April 1860. His father, James Frederick Ensor (1835-87) was British, while his mother, Marie Haegheman (1835-1915) was a Flemish woman from an old Ostend family. The most detailed information about Ensor's family background is given in his *Ecrits,** where he writes:

My paternal grandparents were comfortably off and used to spend part of the year on the continent. My father, their eldest son, was born in Brussels, and he was the only one of their six children who lived in Belgium. He was brought up both there and in England. He started studying medicine in Bonn and Heidelberg, then returned to England, where he was employed by an engineer. He met his future wife when he went with his parents to spend a holiday in Ostend. My father led an intellectual life. He was very sensitive and very gentle, though somewhat haughty in his dealings with some people. His private life was irreproachable. He had tremendous physical strength and he was a man of action, at any rate as far as sport went. I remember one occasion when we went out for a walk together and he flung himself into the sea fully clothed and swam across the channel between two breakwaters. Yet he was also fond of music, and he drew as well. He never felt really at home in Ostend, which was a small town surrounded by ramparts in those days. In the end he set off to look for a job in the United States. The War of Secession interrupted his stay when he'd been there only a few months. He was so depressed when he returned to Ostend that the life seemed virtually to have gone out of him.

Elsewhere he described his father as 'a superior man, whose education... and huge boots inspired fear and terror'.

He defined his mother as 'Flemish, but with a subtle touch of Spanish about her', and added:

* The extracts from *Les Ecrits de James Ensor* and most of the detailed information about his childhood and early career as an artist on which much of this book is based come from a study called 'Ensor par lui-même', printed in the *Revue Générale Belge* in 1960. This was written by the painter and critic Jean Stévo, who was a close friend of Ensor's from 1930 onwards and founded the association called 'Les Amis de James Ensor', which has been responsible for preserving Ensor's house and turning it into a museum. I am extremely grateful to M. Stévo for sending me his study and for putting at my disposal a number of most valuable photographs; he has also very kindly given me permission to reproduce these photographs in this book. I should like to express my special gratitude to him, as he has given me the opportunity to offer a particularly authentic portrait of this great artist.

Her family was an old Ostend one. My Haegheman grandfather was tall, strong and placid. His wife, née Hauwaert, ran a souvenir shop in Ostend, which sold shells and Chinese curios. She was an expert businesswoman and good with money. As she grew older she became hard. Here's one detail about her: when she was about sixty she went to the carnival wearing a costume and mask. The painting called *Woman with a Blue Shawl* (1882) in the Antwerp Museum is a portrait of her.

The ground floor of all the houses in which Ensor lived with his family was taken up with the same shop selling shells and souvenirs for holiday-makers and he preserved it exactly as it was even when he found himself alone and famous. After all, the hotchpotch of objects jumbled together in these picturesque little shops (and picturesque really is the right word) provided him with the props he needed for the still-lifes and masked scenes that he painted so brilliantly.

In case some of my readers may want to follow Ensor as he moved from one set of lodgings in Ostend to another, here is the list: he was born in a house backing on to the old ramparts, which were pulled down long ago; he subsequently lived at 44 Rue Longue, then on the corner of Rue de l'Ouest (now called Rue Adolphe Buyl) and Rue Christine, then he moved back to Rue Longue, living at no. 66 this time, and finally moved to the corner of the Rampe de Flandre and Boulevard Van Iseghem, just a few steps away from the sea, before settling down permanently in 1917 at 27 Rue de Flandre, which is now the Ensor Museum. If you look at a map of Ostend you will see that all these addresses are very close to each other, which is not surprising, as Ensor was well known for his horror of moving and having to change his habits. He hardly ever left the town where he was born and where his genius first began to show itself, except when he studied painting at the Brussels Académie.

Apart from his attachment to the town, its atmosphere and its light, the reasons underlying his obstinate retrenchment were undoubtedly complex. One of his biographers and ardent admirers, the Antwerp critic André de Ridder, who was the leading figure behind the Flemish Expressionist School, has offered the following explanation: 'His withdrawal was partly a deliberate choice, and partly thrust upon him by various circumstances that can only be touched on here — his love for his parents, the inhibited

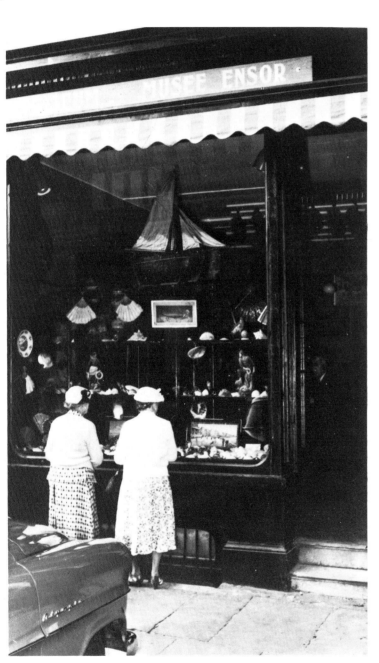

3 The shell-shop at 27 rue de Flandre, Ostend, now the Ensor Museum

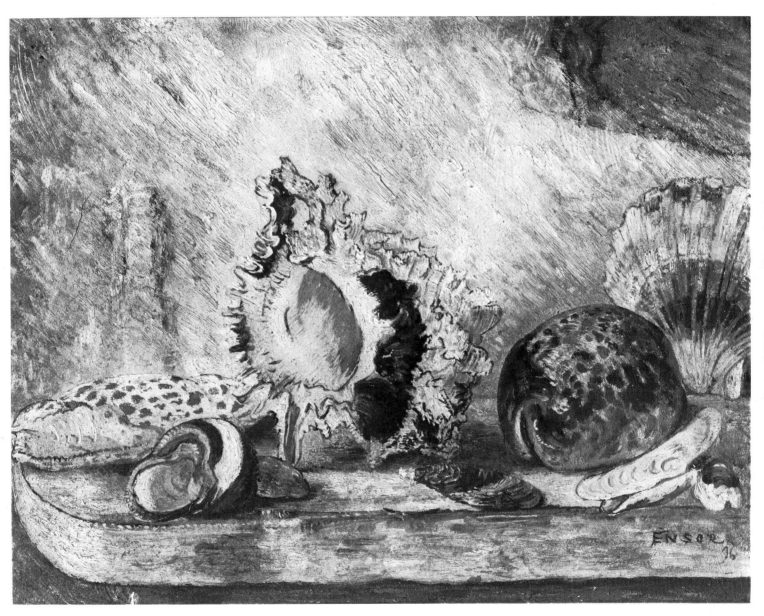

5 *Shells* 1896

overleaf 6 *Shells* 1895

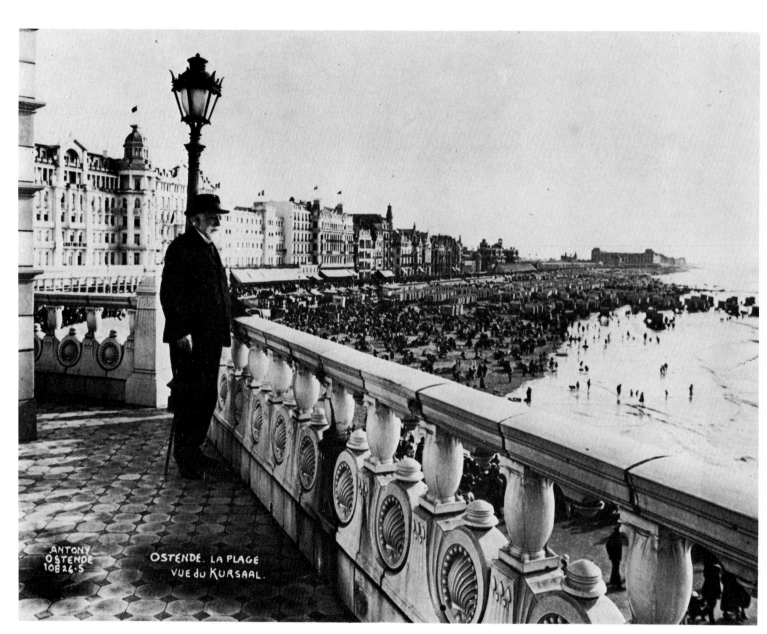

OSTENDE. LA PLAGE VUE DU KURSAAL.

ANTONY OSTENDE 10826·5

7 Ensor on the balcony of the old Kursaal in Ostend

9 Ensor in Ostend in 1926

8 Ensor, the painter Creten and Ensor's niece Madame Daveluy 1928

affections of a hardened bachelor who was fanatically devoted to his art, plus his lack of success and the failure of his ignorant contemporaries to recognize his genius.'

What was Ostend like during Ensor's childhood? He described it as 'a nostalgic little town, encircled by salty ditches, ramparts whose outlines are softened by emerald green on which fairies with merry eyes dance away' — probably not so very different, in fact, from how it was in 1267, when Marguerite de Constantinople granted the town a charter and gave it its first coat of arms. This lively fishing port on the Belgian coast received visitors travelling from Britain to the continent on the mailboat that plied between Ostend and Dover, and it had become a very popular seaside resort. It reached the peak of fashionable popularity when King Leopold II and his family started staying for long periods in the royal 'châlet', their first visit taking place in 1874. Their presence attracted figures from the highest échelons of the aristocracy of Europe and the upper crust of the European business world. It became an even greater centre of attraction when the huge Kursaal (casino) was opened in 1878 and several luxury hotels were built.

The cosmopolitan holiday-makers who thronged the promenade along the pier, and the crowds of bathers jostling on the sandy beaches or among the waves, held little attraction for Ensor. Indeed he found the spectacle positively unbearable and the only works it inspired were a few lively etchings entitled *Bathing at Ostend (Les Bains à Ostende)*, 1899, which were executed in a spirit of caricature. The town he had grown so attached to was not the seaside resort thronged with summer holidaymakers but the working-class town familiar to the local inhabitants. We must turn once again to André de Ridder's book *James Ensor* for a portrait of the Ostend that the painter knew and loved:

In winter the little town houses only the local inhabitants — a few civil servants and tradesmen, whom he ignores completely in his work, and a large number of fishermen. He must often have wandered through the docks, skirting the vast trawlers, the low houses, the stocky figures of the sailors with their poverty-stricken wives and their broods of children. In this fisherman's world you can glimpse some real monsters, with aggressively ugly expressions and a peculiar gait. Their passions slumber behind their ravaged faces until one day during a

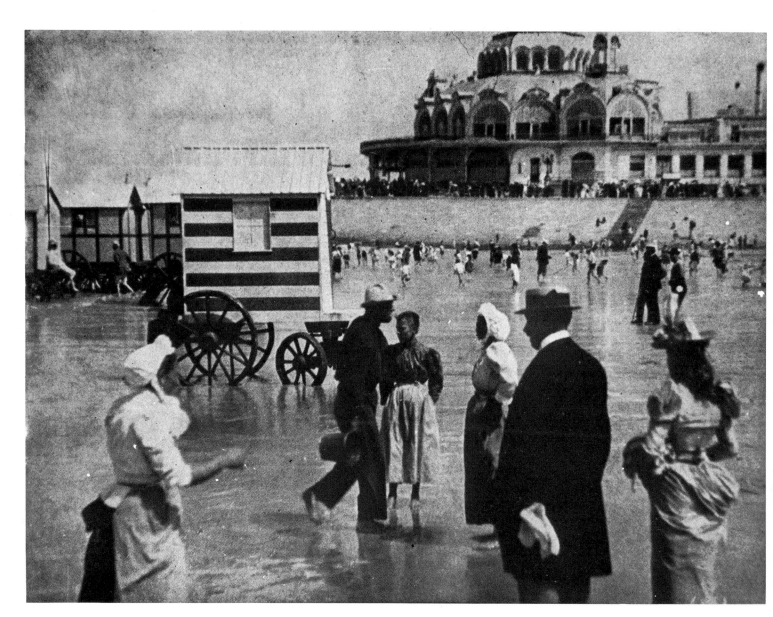

10　The beach and Kursaal in Ostend

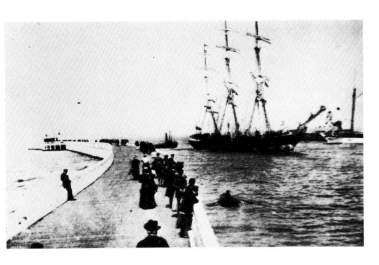

11 Ensor on the breakwater at Ostend

carnival or fair they flare up in a weird sort of debauchery. Among his childhood memories, particularly his memories of the carnivals held in Ostend, Ensor retained horrifying visions of tragic masks and bloated faces seized in paroxysms of mirth.

A number of more personal incidents also helped to arouse Ensor's heightened sensitivity. In his writings he tells us of the emotions he experienced as a small child: 'One night', he relates, 'when I was lying in my cradle with the light on and all the windows open in my room overlooking the sea, a large sea-bird was attracted by the light and swooped down towards me, knocking my cradle as it did so. The sensation was unforgettable. I was crazy with terror. I can still see the horrible sight and I can still feel the shock occasioned by the fantastic black bird greedy for light.' Similarly,

... mysterious tales of fairies, ogres, wicked giants, wonderful rambling stories told at great length by an elderly Flemish servant, a good woman with a heavily lined face, salt and pepper, grey and silver, made a vivid impression on me. Even more impressive was a dark and frightening attic full of hideous spiders, knicknacks, shells, plants and animals from distant seas, fine china, old clothes the colour of rust and blood, pieces of red and white coral, monkeys, turtles, dried mermaids and stuffed Chinamen.

We should also bear in mind the shadowy atmosphere in which the Ensor family lived, with lowered blinds and heavy curtains through which little light penetrated, as in paintings of interiors executed in 1881. The meagre lighting from the oil-lamps or the trembling flame from the bat's-wing gas-burners cast alarming shadows in the corner of the furniture, and the tortured imagination of the sensitive child transformed these shadows into grinning demons. The memory of them was clearly still with Ensor when he engraved *Haunted Piece of Furniture* (*Le Meuble hanté*), 1888.

Yet if we lay too much stress on these childhood emotions we run the risk of concentrating on his unusual qualities as an artist and neglecting his personality as a painter whose art developed and took shape in contact with the splendid countryside round Ostend and the never-failing spectacle of the sea: 'Pure sea, which inspires energy and constancy, with an unquenchable thirst for blood-red sunsets. Yes, I owe a lot to the sea', he once cried enthusiastically.

21

12 Dedication by Ensor on a copy of Paul Fierens' book about him

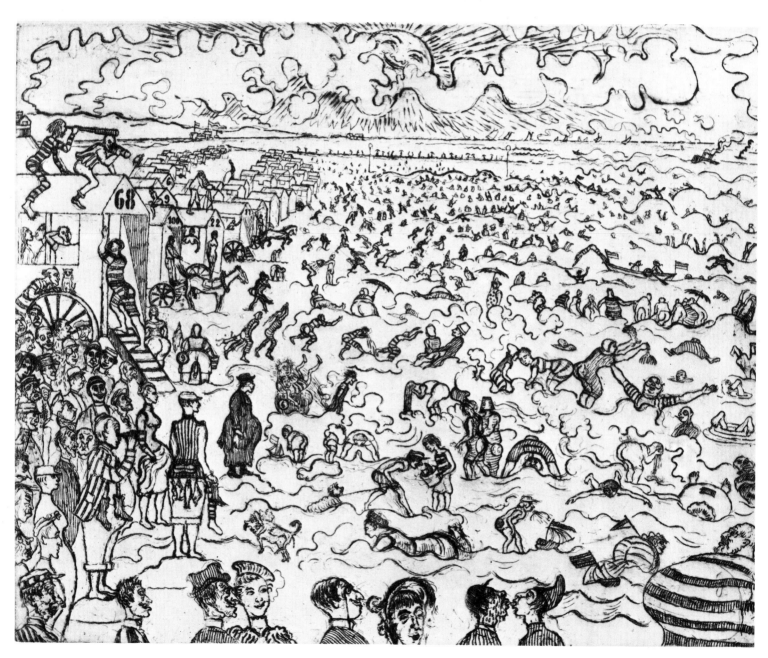

14 The beach in front of the old Kursaal, Ostend *c.* 1910

The Brussels Académie 1877 - 80

Ensor became aware of his vocation as a painter at a very
early age, when he was still at school in fact. He was a
distinctly inattentive pupil, preferring to read in the calm
atmosphere of the family home rather than attend lessons,
or to wander over the dunes that extended on either side
of the town, their greeny-grey reeds trembling in the
sea-breezes. From the top of these hillocks he would gaze
in wonder at the restless and iridescent spectacle of the
North Sea, which was 'the colour of oysters' (to borrow the
poetic yet very accurate phrase coined by Paul Fierens).
Or he might turn to the flat expanse of the green Flemish
plain dotted with the red and white specks of the little
low-slung farmhouses, allowing his gaze to wander as far
as the windmill at Mariakerke, or perhaps a square church
tower on the horizon. This was the landscape that provided
the theme for his first attempts at painting. He was more
or less self-taught at this stage, paying very little attention to
the advice of the insignificant local watercolourists employed
to teach him by his understanding father, who wanted to
encourage his natural aptitude.

Ensor's own account of his first steps as a painter has the
usual touch of irony:

At the Collège Notre-Dame kindly teachers educated me in
a mild and gentle manner. My taste for painting developed at
the age of thirteen, when two elderly Ostend painters pickled in
brine and oil, Van Cuyck and Dubar, initiated me by their
teaching into the disappointing stereotypes of their gloomy,
narrow-minded and stillborn trade. But at the age of fifteen I
was painting views of the countryside round Ostend from life;
I still find these minor and unpretentious works, painted in
paraffin oil on pink cardboard, quite charming.

His account of his time at the Académie des Beaux-Arts
in Brussels is equally detailed and lucid. The idea was to
receive a proper grounding in his chosen trade, but he
already found that he was up against the narrow-mindedness
of the artistic world:

At the age of seventeen I started at the Brussels Académie.
I had been accepted at my first attempt for a course of life classes,
where I was to be ruled with a rod of iron by three teachers
whose accents clashed and who never agreed on anything.
These three men were Joseph Stallaert, Alexandre Robert and Jeff
van Severdonck. Our self-important and fiery principal, Jean
Portaels, who was very highly thought-of, settled all artistic

questions in a peremptory manner. Some of my fellow-students, Khnopff, Duyck, Evrard, Crespin... were bored with their work and did not enjoy it.

Ensor promptly asserted his independence, though this didn't stop him working extremely hard to master his craft:

As soon as I started at the Académie I was overcome with boredom. I was told to paint the bust of Octavius, the most august of the Roman emperors, from a brand-new plaster cast. The snow-white plaster made my flesh creep. I turned it into bright pink goose-flesh and made the hair red, horrifying the other students, though their initial alarm was followed by cat-calls, grins and punches. The teachers were so taken aback by my impudence that they didn't dwell on the fact and from then on I painted freely from living models.

So that I should learn to respect academic art, I drew and wiped down all the plaster casts every evening and I carried off the second prize for drawing from classical busts.

And so for three years I drew from classical models in the evenings and painted from life in the mornings; at night I invented or set down my dreams.

Remembering these years of training and the time when he first became aware of his own personality, he felt both amazed and elated:

I have never understood why my teachers were so disturbed by my anxious experiments. I was guided by a secret instinct, and by an understanding of the atmosphere of the sea that can be inhaled in the sea-breezes, in the pearly haze, drawn up from the waves, heard in the winds... The fantastic somersaults performed by the clouds, with their throngs of fanciful creatures, the dancing mirages, the rasping cries of the seagulls, the high-pitched scales of lovesick mermaids, the long wails of the storm filled me with imaginative joy, with inordinate recklessness. The wonderful ribs on the monumental cabbages and their triumphant shapes haunted me just as much as the harsh lines in David's work, or Delacroix's broken lines, or the plump lines of Rubens, his master, and the august and virginal figures in the fine painting by Ingres in the museum made me shout aloud in a burst of enthusiasm.

We must try to distil from these lyrical outbursts, these retrospective emotions, one or two facts about the time Ensor spent in Brussels, since we have little to go on apart from the details he confided to us in his *Ecrits*. We can deduce from them that although as a young student he rebelled against 'academic' teaching methods he could behave well when he chose and get something from the lessons and

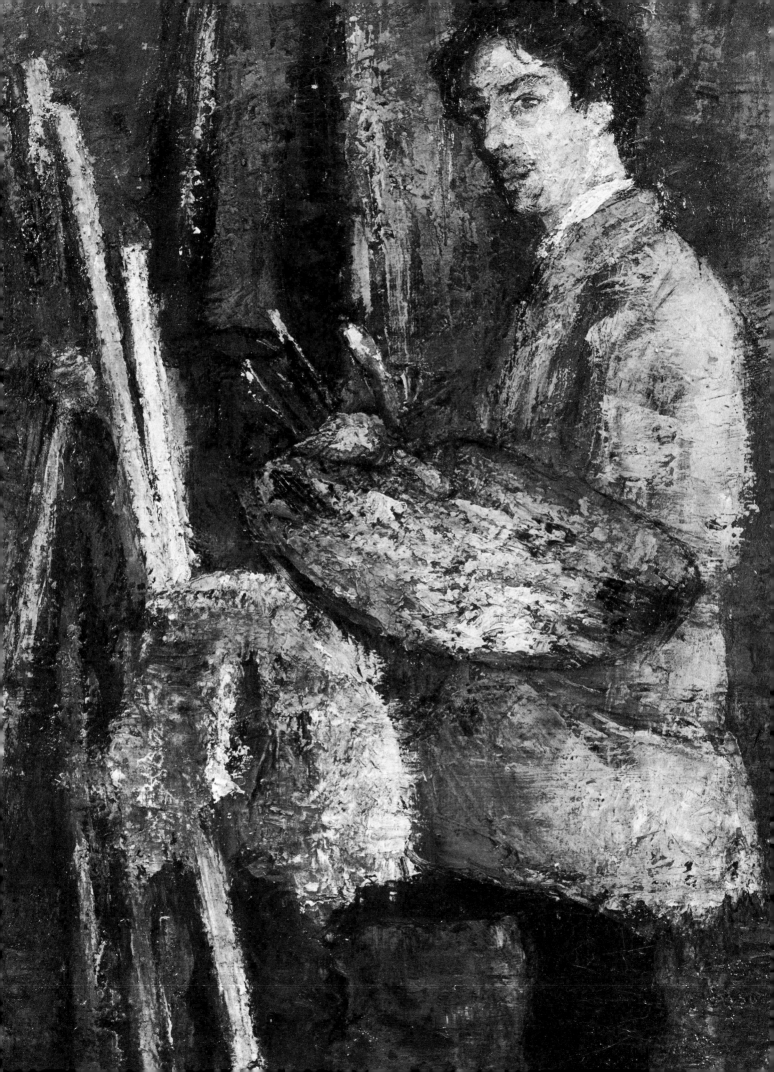

examples he was given. It is clear that his talent had a good deal to do with the amazing precociousness he was to display even before he left the Brussels Académie. His teachers may well have recognized this talent and encouraged him, in spite of the fact that official 'academic' art had been geared to either Classicism or Romanticism ever since artists in Belgium, which had won her independence in 1830, had grafted the influence provided by French painting on to the country's traditional realism.

One of the names that Ensor mentions helps to clarify this situation. Jean Portaels had become famous for the 'oriental' flavour of the paintings he brought back from his travels in Morocco, Egypt and the Lebanon, though in fact his technique remained faithful to the pictorial conventions of the period. He was a pupil and subsequently the son-in-law of François-Joseph Navez, who had himself been a follower of Louis David, the founder of the neo-classical movement during the French Second Empire. Navez had been trained under David in Paris and had followed him into exile in Brussels after the fall of Napoleon. He had also met Ingres in Rome. Oddly enough, when Ensor visted museums as a young man he admired paintings by David and Ingres just as much as those by Delacroix and Rubens, whom we might expect to be closer to him in temperament. Also, it doesn't seem as though he was familiar at this stage with the work of more modern French painters who might have had a genuine influence on him. He certainly did not know the work of the Impressionists, who were only just beginning to emerge as a group. They were not welcomed by the 'Les XX' group until a few years later and their work was not widely shown until the 1894 salon of the 'Libre Esthétique', by which time Ensor's major work was already behind him.

At the age of nineteen he was already painting some canvases that are clearly the work of a great artist. Without making concessions to the Flemish Realist painters' fondness for 'crusty, rich and runny pastry, and oily, buttery, souped-up stews', which he used to poke sly fun at, his technique in these early paintings largely involved thick paint applied with accurate brushstrokes or slapped on with a knife, with steady tones making the surface seem to vibrate from below. The paintings in question are *Self-Portrait of the Artist* (*Portrait de l'artiste par lui-même*), in which he is depicted standing in front of an easel with his palette in his hand, and *Woman with a Turned-up Nose* (*La femme au nez retroussé*), in the Antwerp Museum.

Where did he paint these two canvases, both of which are dated 1879? Perhaps in a furnished room in Brussels between classes, or when he was on holiday in Ostend. We only know that he himself noted: 'Then I painted a humble servant, the woman with a turned-up nose. I was also preoccupied by the spectacle afforded by the streets and my pictorial appetites were developing. I sketched passers-by, apples, poultry, blue flasks...'. But we know that all these various still-lifes were painted the following year, when he had left the Académie and returned to Ostend.

'In 1880 I emerged unceremoniously from that place full of short-sighted creatures, already saturated with antiques, satiated, lashed by the compliments rapped out by my foul-mouthed teachers.'

The heyday of Ensor's art was beginning. It was a period full of extraordinary pictorial events and it was to last for exactly thirteen years, between the ages of nineteen and thirty-two.

16 *Woman with a Turned-up Nose* 1879

overleaf 18 *The Blue Flask* 1880

17 *Self-portrait* 1879

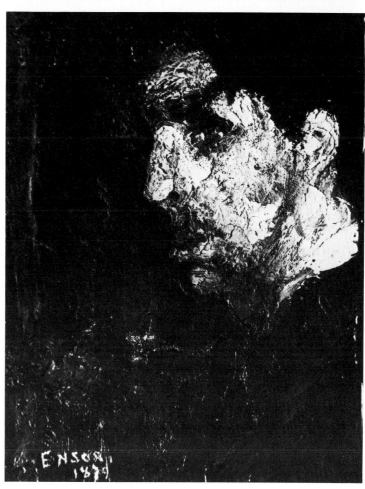

29

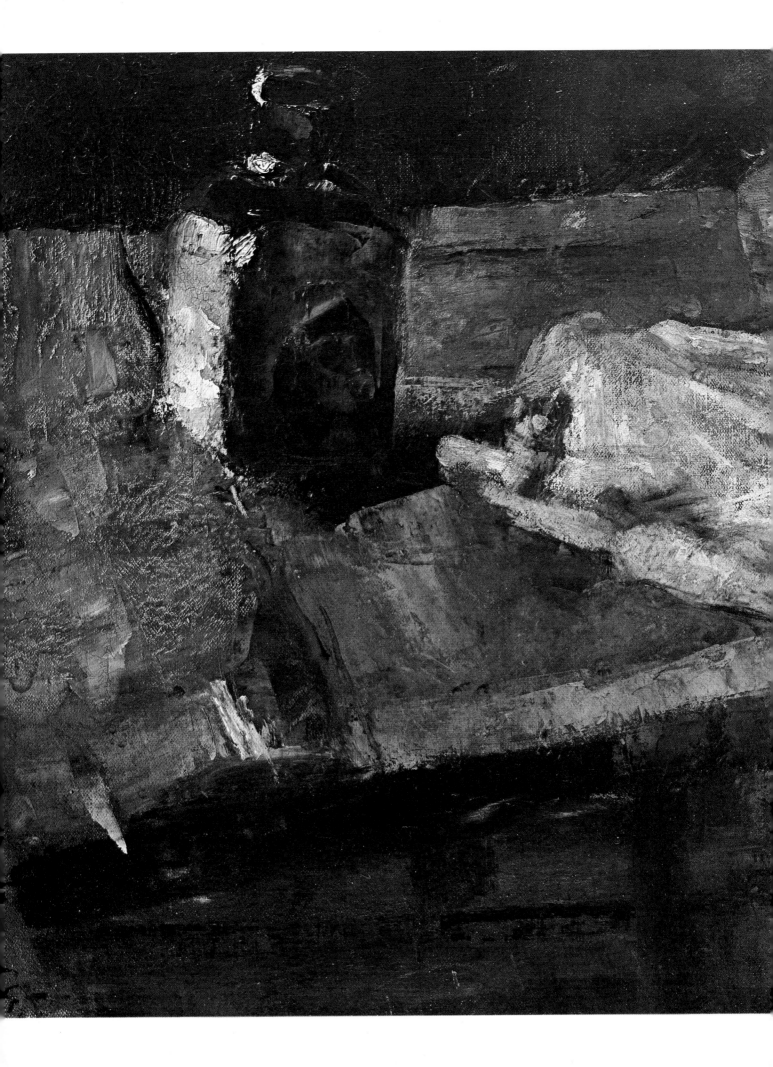

Intimist Period 1880-82

The moment he was back in his parents' house in Ostend and free from academic constraints Ensor set to work, painting feverishly and obstinately. He was extremely prolific at this period tackling a very wide range of *genres* — landscapes, still-lifes and portraits. Soon after his return he also painted the first of a series of domestic interior scenes that are the indisputable masterpieces of this early period. Ensor specialists have labelled this stage of his career his 'dark period', in contrast to the 'light period' that followed it. The 'light period' was marked by much brighter colouring and Ensor was shortly to evolve a range of pure colours that were eventually transformed into bursts of colour harmonizing together in extremely subtle combinations. Yet although blacks and brown or ochre earthy colours predominate in the paintings of the 'dark period' and they are often full of shadow, or at any rate of half-light, the whole canvas is bathed in filtered light, which clings to the contours, enveloping certain shapes. Sometimes, as in *The Colourist (La Coloriste)* of 1880, there will be patches of colour virtually on the edge of the frame, giving the tone to the scattered patches of reflected light that echo them.

During this same year the luxuriant shapes and sensual subject-matter of his first still-lifes (*Still-life with Duck* [*Nature morte au canard*] and *Apples* [*Les Pommes*]) show that his early work still bears a few traces of the influence of Flemish Naturalism. But even in his *The Blue Flask (Le Flacon bleu)*, a small masterpiece of great pictorial richness, he had already managed to escape from any form of regional tradition and had attained some degree of intellectual subtlety in his treatment of objects.

In the lonely figure of the young *Lamp Boy (Le Lampiste)*, the skilfully contoured patches of deep black enliven the somewhat massive silhouette outlined against a whitish partition-wall. The art-historian Francine C. Legrand, Curator of the Musée d'Art Moderne in Brussels, which acquired the painting in 1896 (it was the first of Ensor's paintings to be bought by the State), describes *The Lamp Boy* and makes some apposite comments:

In his first period Ensor liked painting people taken from everyday life. We can hardly see the face of this child holding a lamp with his head bowed. He is merely a black mass standing out against a beige wall. This painting has been compared to

31

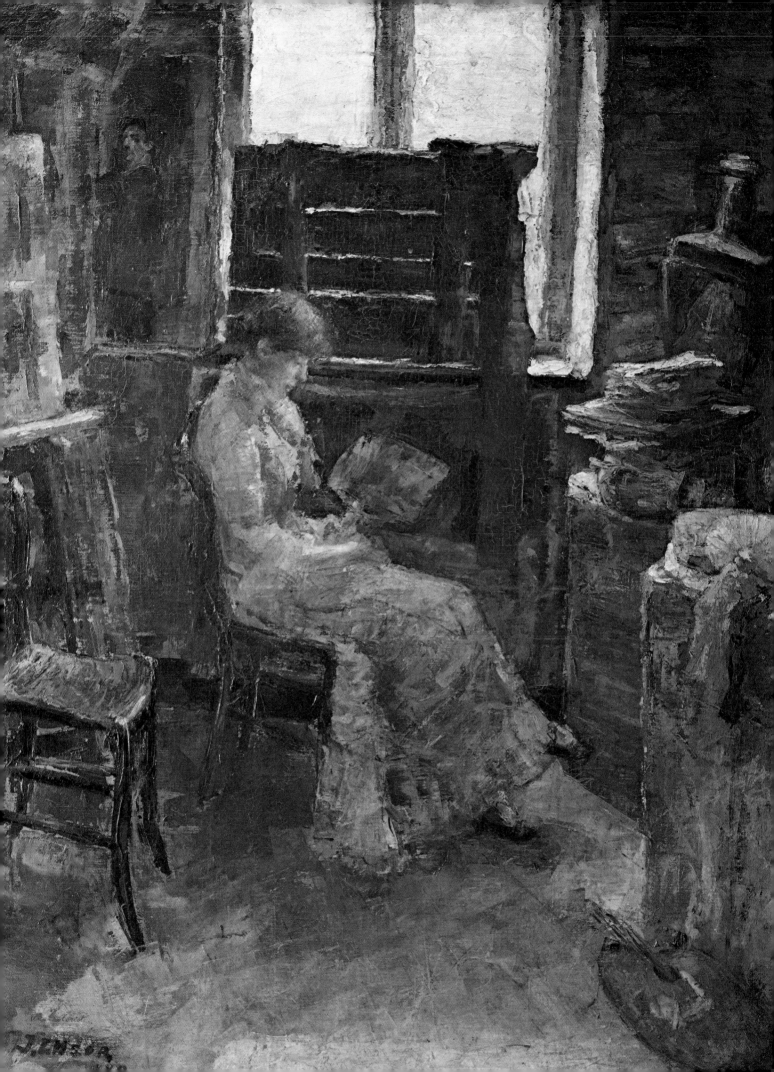

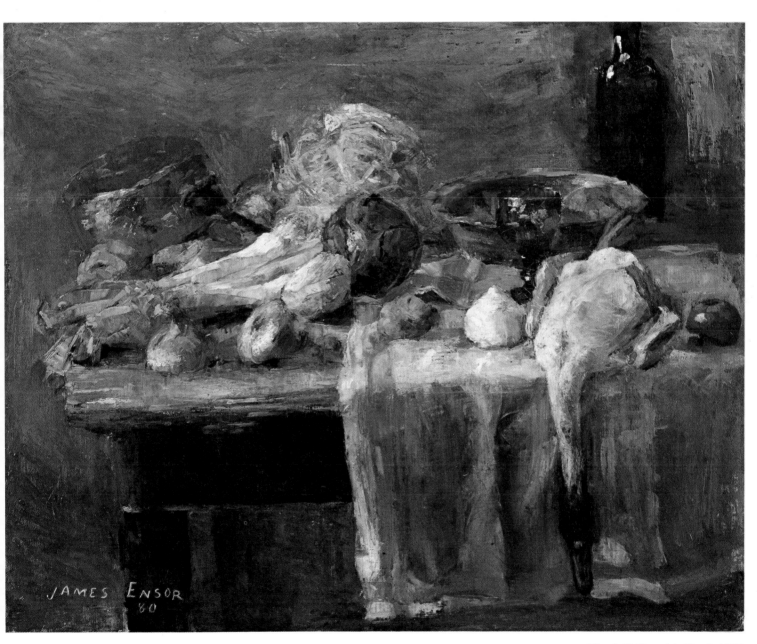

20 *Still-life with Duck* 1880

19 *The Colourist* 1880

33

22 *The Dark Lady* 1881

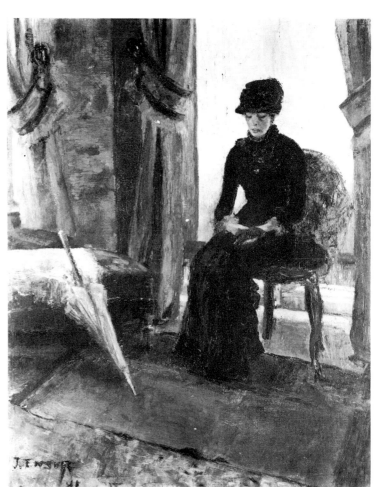

21 *The Lamp Boy* 1880

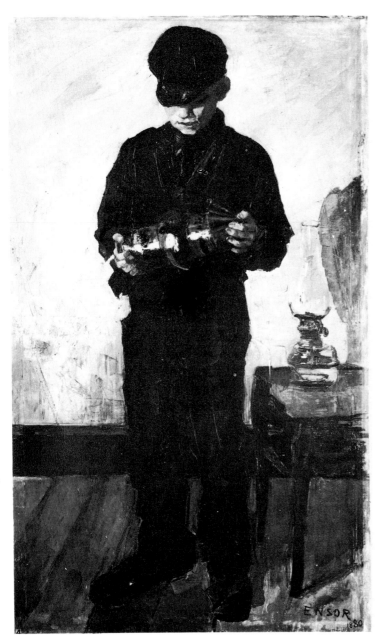

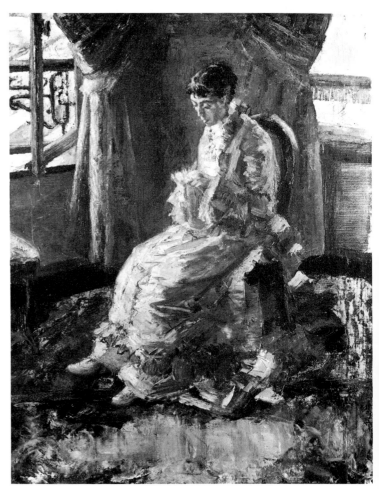

23 *Lady in Blue* 1880

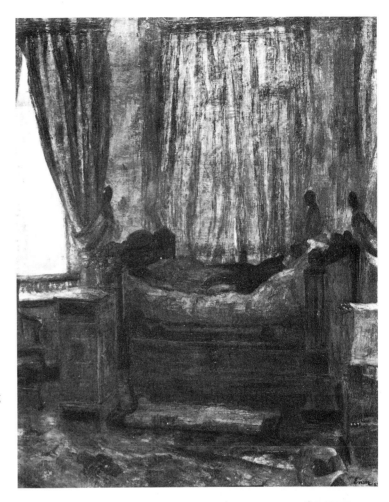

below 25 *Tramp Trying to Get Warm* 1882

Manet's *Fife-player* [*Le Fifre*], which was painted a few years earlier* and which offers the same contrast of a figure outlined against a light background. But experts have also pointed out that this was merely a superficial comparison. Quite apart from Ensor's black being deeper, more heavily 'veiled', whereas the fife-player is a broad flat-tint in black and red boldly silhouetted, the lamp boy achieves the impossible by bringing out the inner modelling of the face, with black contoured against black.
The lamp too represents a victory over the impossible, its copper alive with reflections and creating an incandescent centre among all these shadows.

The same three-dimensional properties of black can be seen in the large charcoal sketches dating from the same period. In these Ensor demonstrates his mastery of the draughtsman's art, which he had presumably acquired during his studies. (See *The Young Sailor* [*Le Jeune Marin*], *The Old Fisherman* [*Vieux Pêcheur*], *The Boy* [*Le Garçon*], *Woman with a Broom* [*Femme au balai*] and *The Serving-Woman* [*La Servante*].)

Although during this early stage in his development Ensor had not yet reached the point of moving beyond the limits of reality to give shape to his imagination, he was clearly concerned in much of his work to spiritualize his subject-matter and to distil the expression of a feeling from his perceptions and emotions. In such cases it is noticeable that it is most often the subtly emphasized use of black that gives his compositions their emotional resonance. In the way he uses it black indicates either loneliness or drama. In *The Dark Lady* (*La Dame sombre*), for instance, it represents the loneliness of the seated figure waiting in an empty room while in *Lady in Distress* (*La Dame en détresse*) it symbolizes a dramatic situation, with the languid figure laid out as though crushed by grief, scarcely visible on a huge bed set high off the floor. Black is again the dominant colour, simultaneously expressive and symbolic, in the canvases devoted to human grief. Examples of these, which were painted shortly after, are *Tramp Trying to Get Warm* (*Le Pouilleux se chauffant*) of 1882 and *The Drunkards* (*Les Ivrognes*) and *The Oarsman* (*Le Rameur*) of 1883. The last of these can match in strength the most powerfully built of the sailors painted forty years later by the

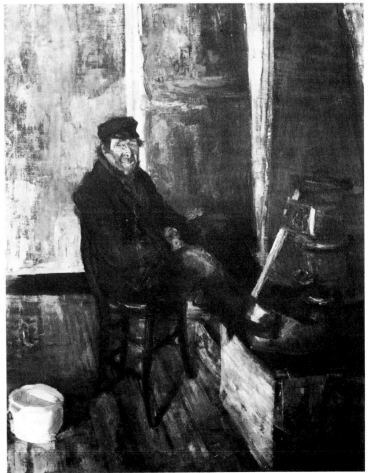

* The *Fife-player* is dated 1866, when Manet was thirty-four, whereas Ensor was only just twenty when he painted his *Lamp Boy*.

26 *Russian Music* 1881

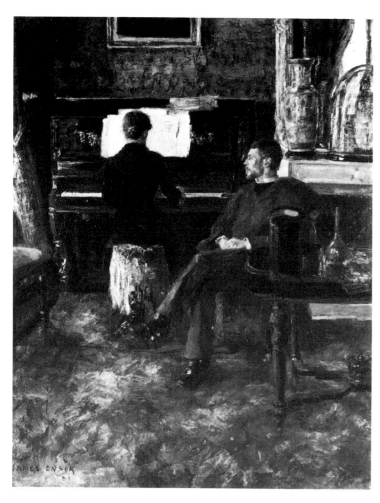

Expressionist painter Permeke, another artist who hymned
the back-breaking lives of the fishermen of Ostend.

Ensor was not restricted in the people round about him
to these touching figures suggesting dark and troubling tones.
The everyday life of his family provided him with models
for intimate portraits and themes for peaceful little scenes.
These offered a pretext for a subtle play on subject-matter
and for rich tonal harmonies that enabled him to recreate
the warm and confined atmosphere of a comfortably well-off
domestic interior. So at the same time as he was painting
the dark canvases Ensor also executed a series of more
colourful paintings. As well as *The Colourist* the year 1880
also produced two portraits — *Lady with a Fan* (*La Dame
à l'éventail*), *Lady in Blue* (*La Dame en bleu*) — and his

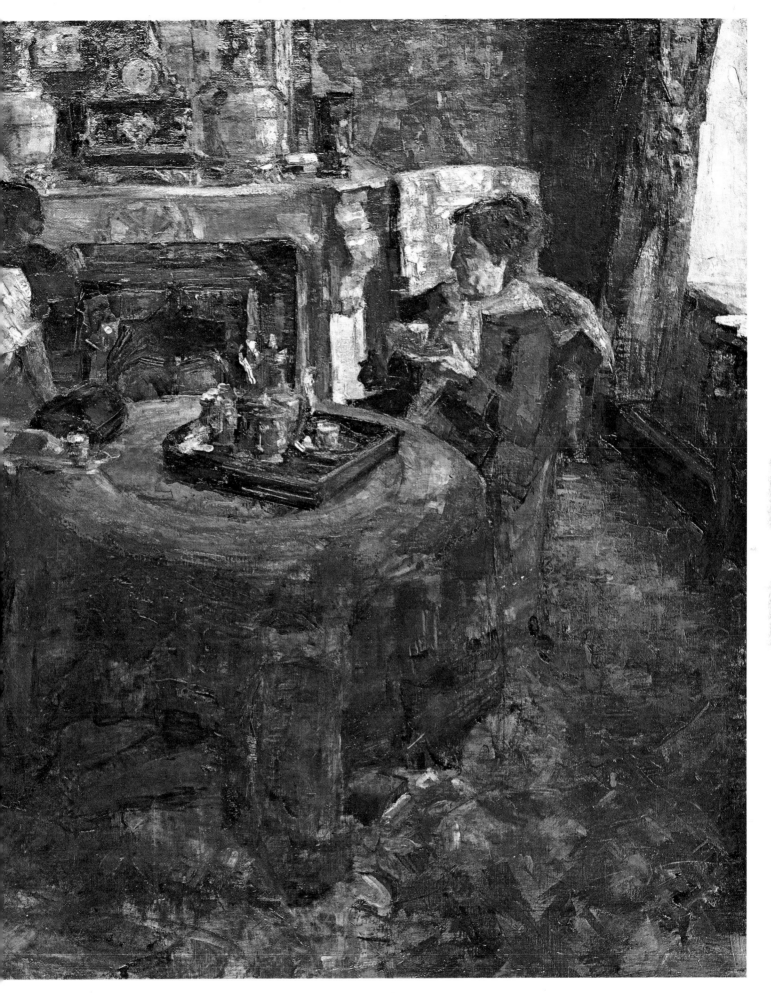

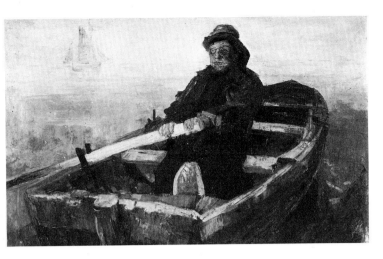

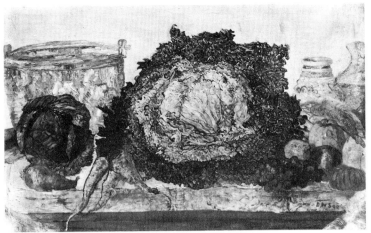

above, left 29 *The Oarsman* 1883

above, right 30 *Kale* 1892

opposite 28 *Middle-class Drawing-room* 1880

overleaf 31 *The Skate* 1892

first *Middle-class Drawing-room* (*Salon bourgeois*). These were followed in 1881 by the two lively domestic scenes called *Afternoon in Ostend* (*Après-midi à Ostende*) and *Russian Music* (*La Musique russe*), as well as another *Middle-class Drawing-room*, a later version of the brilliant sketch of the previous year. Incidentally, just a note on the title Ensor gave to his canvas *Russian Music*, which depicts a woman playing the piano seen from behind, with a seated man listening to her playing: curiously enough, the music of the younger generation of Russian composers was not introduced to the people of Belgium until 1885, when a concert of the work of the 'Group of Five' was given in Liège.

The chromatic brilliance and restrained light-effects in paintings of this kind already belie the 'dark period' label that is generally accepted for the whole group of works to which they belong. It would surely be preferable, considering that virtually all the subjects he used at this period originated within his family, to refer to these paintings as 'Intimist'. Incidentally, comparisons have been drawn between the 'domestic interiors' painted by the young Ensor and those by the archetypal Intimist painter, the French artist Edouard Vuillard. Vuillard resembles Ensor in that he made his home and his mother's hat shop his studio and based his work on them. Then again, like Ensor, Vuillard lived with his mother until her death, and never married. But the various points of similarity that we can detect in the mood and atmosphere of the domestic scenes painted by the two artists do not imply that one influenced the other, because when Ensor was painting his 'Vuillard-esque'

'drawing-rooms' Vuillard himself was only fourteen and still at school. He didn't start painting until 1888 (the year when Ensor was painting his *Entry of Christ into Brussels* [*L'Entrée du Christ à Bruxelles*]); and the first of his domestic interiors that can be said to resemble Ensor's chiaroscuro effects were not painted until 1893.

Instead of insisting on a somewhat arbitrary parallel between Ensor and Vuillard it would be more plausible to point to a direct link between Ensor's Intimist paintings and the poetic feeling for everyday life revealed by an older Antwerp painter, Henri de Braekeleer (1840-88). De Braekeleer was one of the first Belgian painters to add a few bright notes to the gloomy palette with which the academic Realists continued to fabricate the 'souped-up stews' that so repelled the young Ensor when he escaped from school. A small painting by De Braekeleer in the Antwerp Museum, *Props for Still-lifes* (*Accessoires de natures mortes*), painted in 1875, already had the richly luminous quality with which Ensor bathed the warm atmosphere of his *Afternoon in Ostend*. He was to develop this to its extreme limit in his own still-lifes, such as *The Skate* (*La Raie*) or *Kale* (*Le Chou frisé*), and in the 'multicoloured cast-offs' he used for his masked scenes. But it was not until 1885, after the nervous breakdown that had brought his work to a standstill between 1880 and 1884, and indeed shortly before his premature death, that De Braekeleer was to 'affirm the supremacy of colour that gives light and at the same time moulds form and suggests the subject-matter', as F.C. Legrand noted. This applies to *The Meal* (*Le Repas*), and particularly to *Working-class Woman* (*La Femme du Peuple*). Legrand rightly concludes: 'He is behaving at the moment as a daring innovator, taking his place alongside Ensor, who is twenty years younger.'

Many years later Ensor paid homage to De Braekeleer in the following terms: 'Let us remember the great painter De Braekeleer, who was thought to be unintelligent and limited. The bigwigs in financial circles referred to him as "innocent"; and the word was taken up by the rough lords of the *quais*. Lucky De Braekeleer! Let's follow his example and restrain the curiosity of the vulgar throng; any form of communion with the impure of this world brings about a speedy decline in the artist's living forces.'

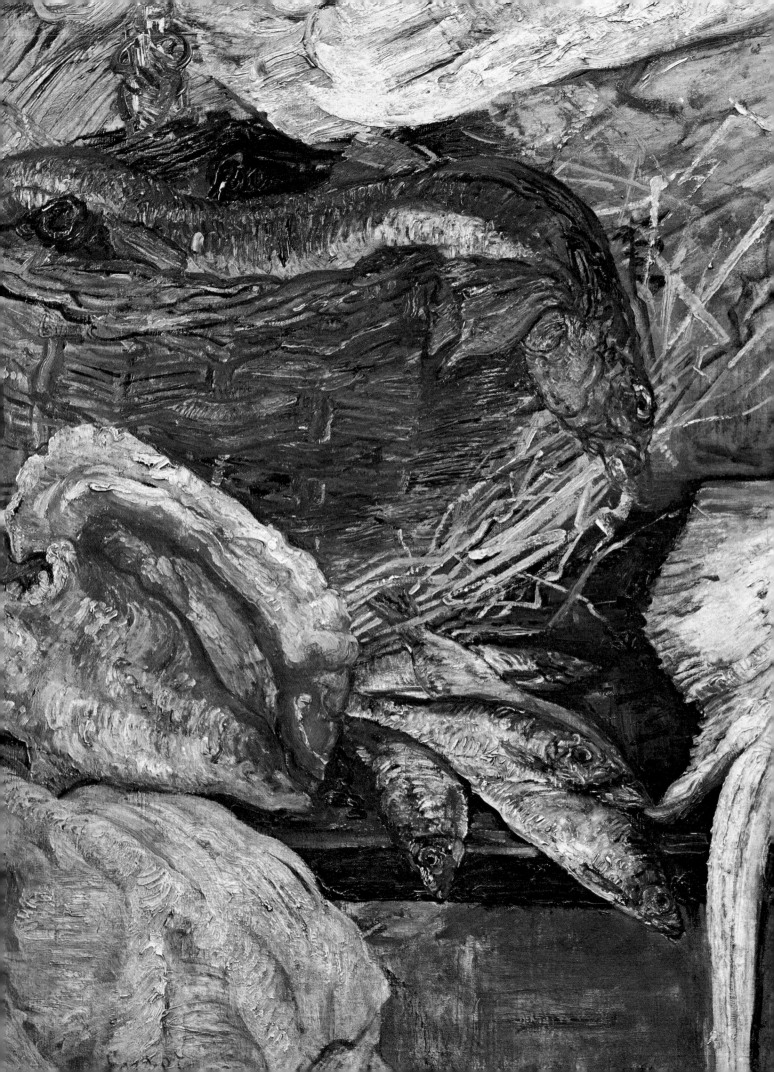

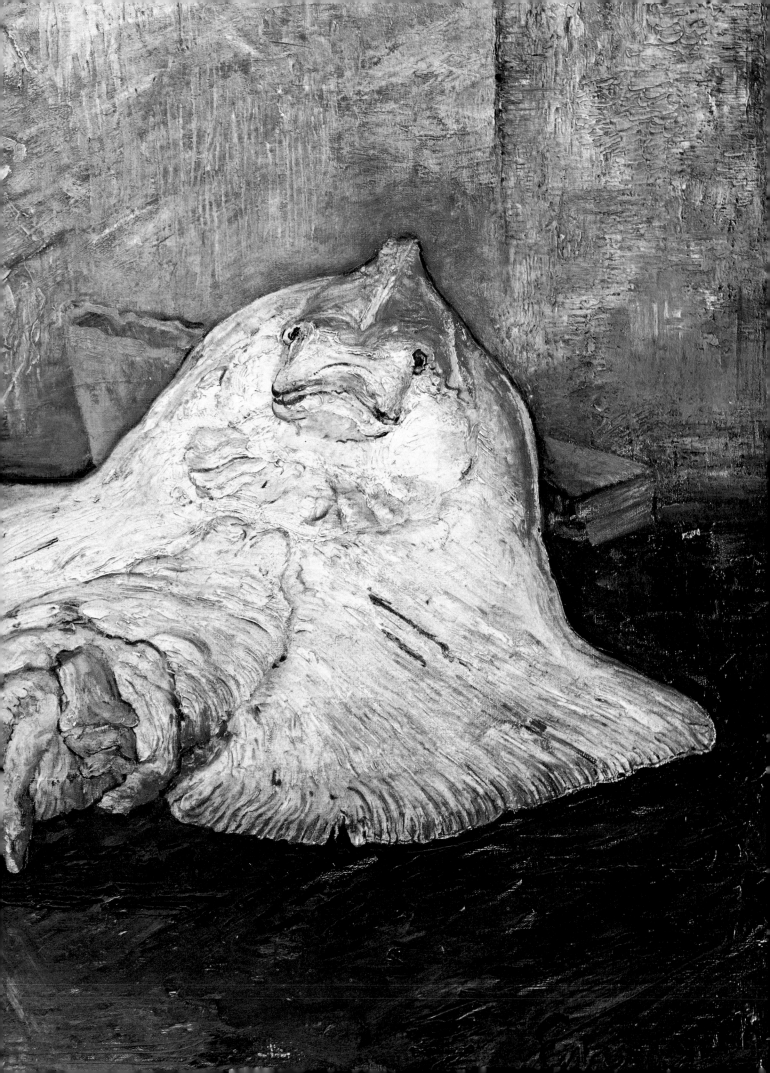

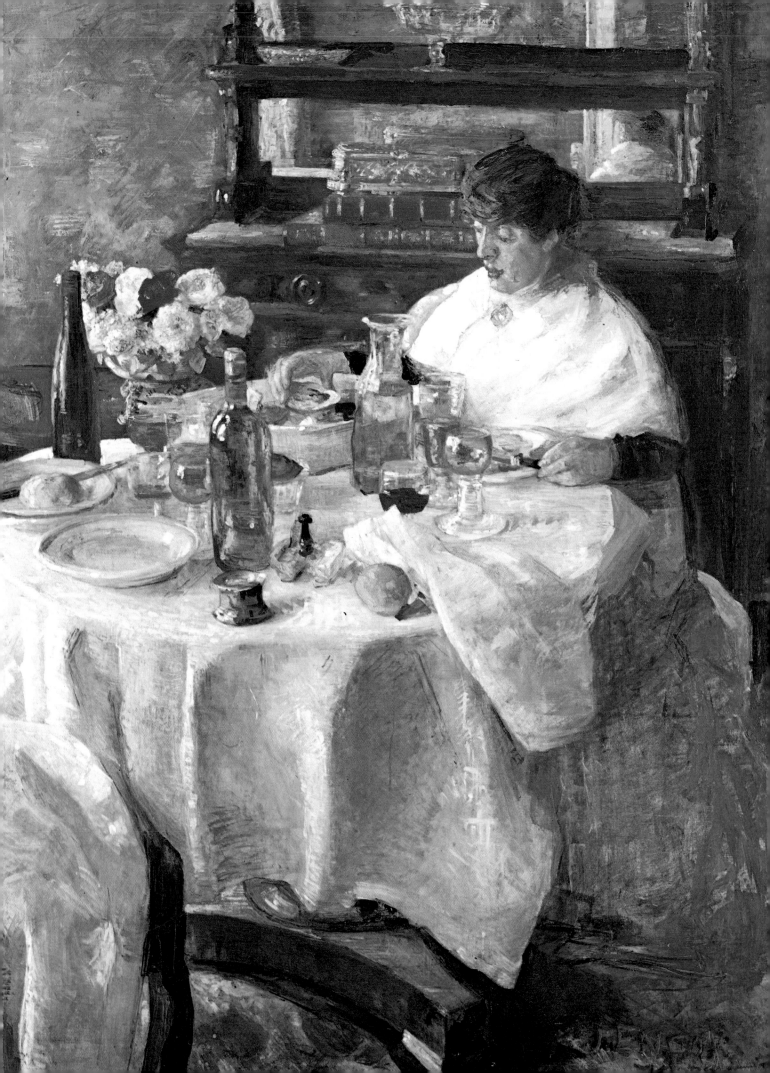

Ensor And Impressionism:
Woman Eating Oysters 1882

Woman Eating Oysters (*La Mangeuse d'huîtres*, Antwerp
Museum) marks an important stage in Ensor's career.
In a way it can be seen as providing a link between the
chiaroscuro effects of his early paintings and his victory over
colour and light. He is again dealing with a domestic
interior scene in this canvas (measuring 2 x 1.50m), and he
has remained true to the reality and density of objects,
examining them closely and itemizing them with the same
meticulous realism as De Braekeleer. Yet in spite of this,
and in spite of the fact that he has made the still-life in the
foreground more important than the figure of the woman
sitting at a table (who indeed appears to be there solely to
provide a patch of light colour and thus draw out the light
from the white tablecloth), it is clear that his main aim was to
capture the fleeting sensation of reflections and the
transparent effect of shadows. This might perhaps justify
those who have pointed to a link between Ensor's 'light
period' and Impressionism.

But this view should be approached with considerable
caution; it needs to be examined carefully and restated.
We must first of all take into account the important comment
by Paul Haesaerts, in his *Histoire de la Peinture Moderne
en Flandre*. In the introduction to the chapter on Ensor
he says:

Belgium has — and Paul Fierens is right to stress this historical
point — two types of Impressionism. These made themselves
felt and developed in parallel, converging at certain points,
sometimes failing to understand each other, but in the end merging
together and being rejected wholesale by new aesthetic theories.
One version of Impressionism is home-grown. It emerged within
Belgium from the final stage reached by some of the Realist
painters. The other version was imported. At a very early date
the Brussels circle known as 'Les XX', led by the daring and
experienced critic Octave Maus, exhibited the work of the French
painters who had invented the new formula and this was taken
up with great enthusiasm by their Belgian followers.

But having recognized that 'in this way, thanks to the
simultaneous combination of spontaneous combustion and
outside pressures, Impressionism invaded the whole of Belgian
painting', Haesaerts promptly makes a reservation:

Although the influence of Impressionism was all-pervasive, no
Belgian painter had complete confidence in the new movement
or felt entirely at home with it; none of them managed to develop

32 *Woman Eating Oysters* 1882

43

his talents fully, and yet remain completely faithful to Impressionism, as Turner or Monet did — though such a situation was unusual in all countries. Few great painters were satisfied with Impressionism alone and only very few, such as Cézanne, Van Gogh or Ensor, did not try to escape from it in some way.

Yet in 1882, when Ensor was painting *Woman Eating Oysters*, the Impressionist movement was still largely unknown in Belgium. Whereas in France the transition from Naturalism to Plein-Air painting and Impressionism was undertaken by Claude Monet, Pissarro, Sisley and Renoir somewhat earlier than 1870, and the public exhibitions held by the Impressionist group in Paris were spread out over a period lasting from 1874 to 1886, canvases by Renoir and Monet were not shown in Belgium until 1886. This first exhibition was staged by the 'Les XX' group in Brussels, who very shortly afterwards introduced into Belgium the Pointillist technique invented by the Post-Impressionists, showing Seurat's painting *Sunday at the Grande Jatte* (*Le Dimanche à la Grande Jatte*) at their 1887 Salon. But there is no question of the French Impressionists having had a direct influence on Ensor, because before they were introduced into Belgium he had already turned clearly and decisively to the use of light colours and plenty of light in his paintings. In 1911 he could state without exaggeration: '...Thirty years ago I pointed the way to all the modern experiments, to the whole idea of the influence of light and freedom of vision, long before Vuillard, Bonnard and the Luminist painters.'

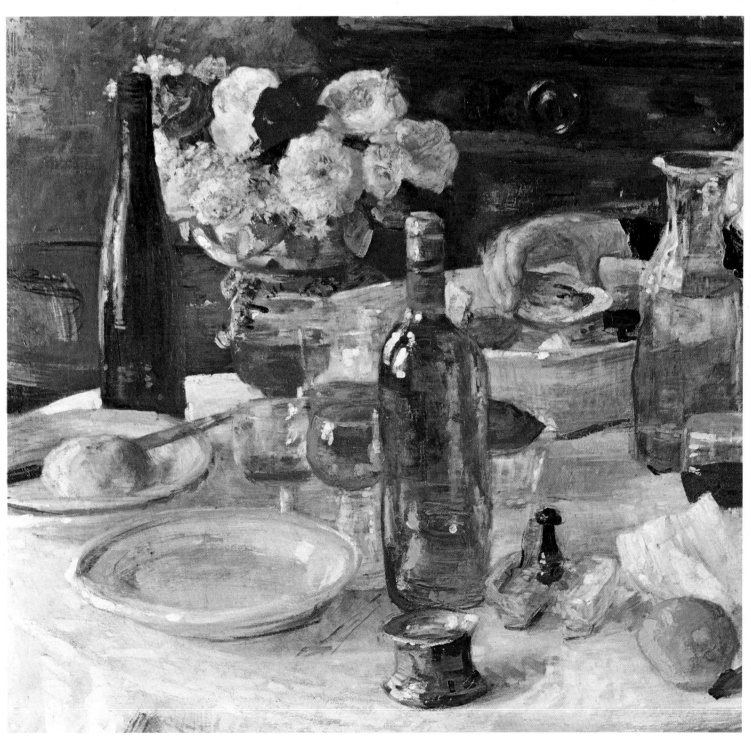

The Years of Transition

For a few more years Ensor confined his painting to the sphere of domestic reality that he could observe in his everyday life. But his instinctive enthusiasm, combined with his exceptional sensitivity and his technical mastery, were enough to make him stand out from his contemporaries.

In a preface to the large retrospective exhibition of Ensor's work held at the Musée National d'Art Moderne in Paris in 1954, the Chief Curator of the Musée Royal des Beaux-Arts in Antwerp, Walter Vanbeselaere, published the most sensitive and penetrating study of the Belgian painter's work that has yet been written. In it we find an accurate analysis of the many and very varied paintings he produced during this intermediary period. After discussing the paintings depicting the human figure, particularly female figures, that belong to Ensor's Intimist period of 1881 and 1882, he writes:

At the same time Ensor also painted the sea, sometimes in ashen-grey tones with brilliant touches of ochre that remind us of the mellow work of Corot; but elsewhere he shows us a dark and threatening sea, or else a sea overhung by dazzlingly blue skies. Then we find still-lifes, street scenes, with their changing colours and their light-effects governed by the atmospheric conditions. All these offer us new revelations, uninterrupted evidence of the painter's undying inspiration.

This observant critic then examines Ensor's development, which was already becoming clear in some of his paintings, and adds:

Guided by his infallible instinct for discovery, he suddenly turned in 1883 to areas that he had not yet touched on; these were much vaster, more worrying and richer in phantasmagoria than all the hidden mystery he had discovered in the real world about him. In his *Christ Walking on the Water*, or in *The Oarsman*, or *Ensor in a Flowered Hat*, or *Scandalized Masks*, and also in *Portrait of Vogels at the Easel*, his imagination shies away from anything resembling direct observation and aims instead for murky regions where light and shadow embrace with never-failing tenderness, or else collide with indescribable brutality; but in the end they remain irresistible forces, attractive or repellent forces born of the abyss.

Yet most of the canvases that Ensor painted at this period were still Naturalist works, both in their pictorial interpretation and in their traditional subject-matter. In fact we can still list still-lifes, such as *The Hare (Le Lièvre)*

overleaf 35 *Music in the Rue de Flandre* 1891

36 *Rue de Flandre in the Snow* 1880

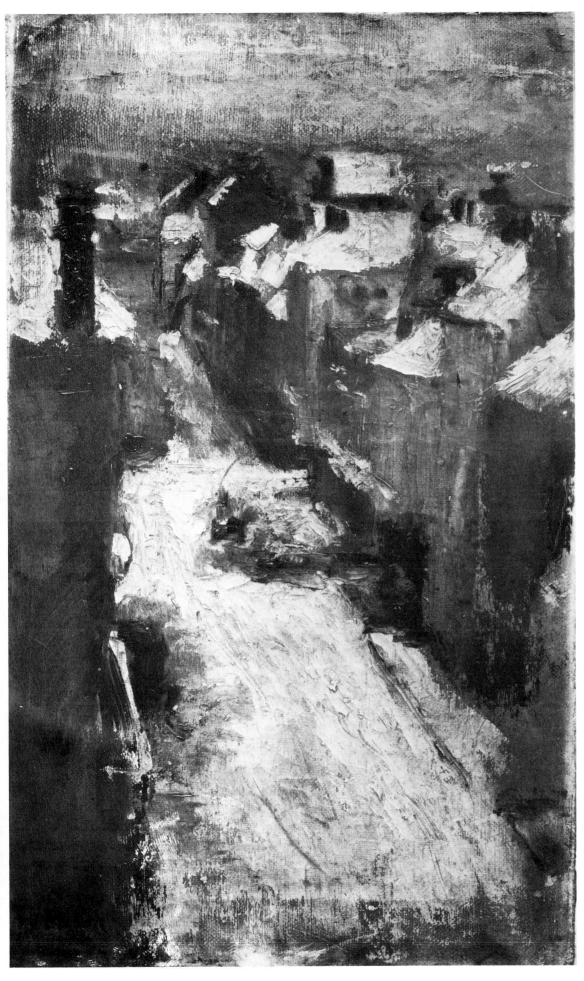

49

37 *The White Cloud* 1882

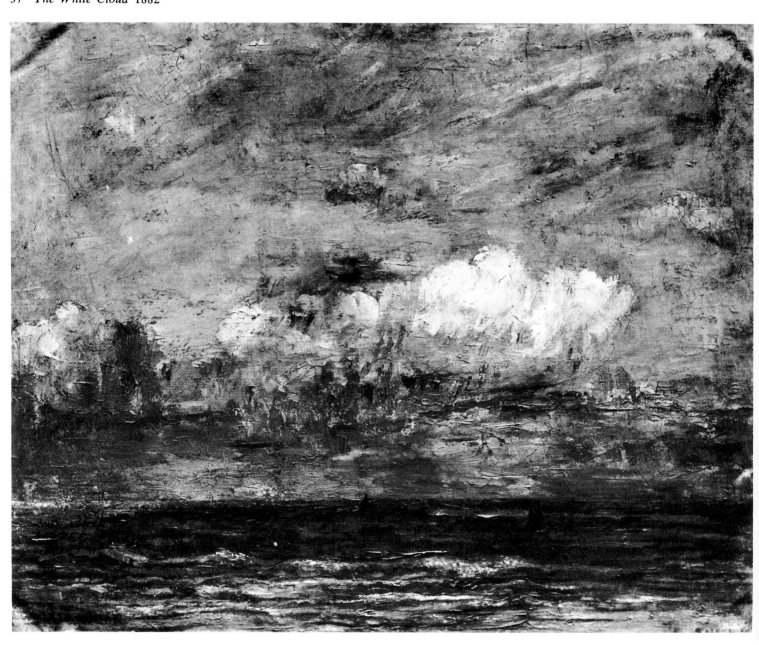

38 *Portrait of Ensor in a Flowered Hat* 1883

of 1885, that have the same material quality as the ones he painted in 1880; and in particular we find a considerable number of large and small seascapes, the most important being *The Breakwater* (*Le Brise-lame*), 1882, *The White Cloud* (*Le Nuage Blanc*), 1882, *Ostend Lighthouse* (*Le Phare d'Ostende*), 1885, as well as a few urban landscapes that betray a very individual point of view in their observation. *Rue de Flandre in Ostend* (*La rue de Flandre à Ostende*), painted in 1881 and seemingly the most 'Impressionist' of Ensor's paintings with its effect of sunshine, can be likened to Manet's and Monet's streets hung with bunting. But it is striking that, as with *Rue de Flandre in the Snow* (*Rue de Flandre sous la neige*) of 1882 and the small canvas in the Antwerp Museum called *Music in the rue de Flandre* (*Musique rue de Flandre*), 1891, we are looking down on to the street from the rooftops. And don't forget that these roofs were used in their turn as the subject of paintings such as *Rooftops in Ostend* (*Les toits à Ostende*), 1884, or *View of Ostend* (*Vue d'Ostende*), 1898.

In his monograph on James Ensor (Paris: Rieder 1930) André de Ridder describes the conditions under which the painter chose to work and which explain the unusual appearance of his landscapes. The studio he used from 1880 to 1917

... formed part of the wedge-shaped house on the corner of the Rampe de Flandre and Boulevard Van Iseghem, only a few paces from the sea. These premises also housed Ensor's parents' shop, as did all the other houses they lived in, and the son's study had been installed on the fourth floor, up in the attics. There were five windows altogether. The main one faced due south, while two other small attic windows faced south-east and the last two south-west. The four small windows let in the light about six feet up from the ground. The large bay window, which was at chest height, overlooked part of the town and the odd glimpse of the countryside gave the perfect finishing touch to a magnificent horizon. Ensor always liked painting his landscapes panoramically, looking down from a window and thus as it were overhanging whatever spot he wanted to interpret. This explains the oblique angle of vision in his paintings, which has often surprised people. It is in fact one of the characteristic features of an Ensor landscape, perhaps the most important one, together with the beauty of the splendid skies tossed with wispy scattered clouds, so poignant and subtle, that he conjured up over the sea, the dunes or the rooftops. So this perspective clearly wasn't chosen arbitrarily, or even deliberately adopted

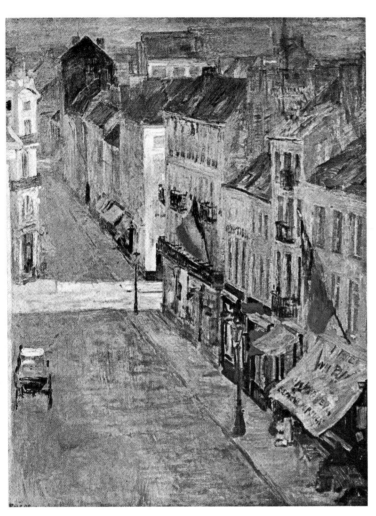

40 *Rue de Flandre in Ostend* 1881

overleaf 42 *Beach Carnival* 1887

as such. Rather it resulted fom the material conditions under which the artist had to work on his canvases, using a perspective with planes sloping fairly sharply downwards. Also, the lighting in his studio-bedrooms was not the same as the cool uniform light that is diffused in traditional north-lit studios, but was softer, more all-enveloping.

The main reason why Ensor painted his landscapes from his window, rather than setting up his easel in the street, may well have been to avoid the hostility of his neighbours, who were local dignitaries or tradesmen. Whereas he felt perfectly at home among the ordinary people in the working-class districts he found little pleasure in the company of the middle class in Ostend. Jean Stévo has explained the reason for his distrust of them, which incidentally was mutual:

Just imagine the reaction of his fellow-citizens to the artist living in a small town like Ostend. Why didn't this so-called painter, who was constantly greeted with jeers and sarcastic remarks, 'do an honest day's work'? Why wasn't he a good tradesman like them — logical, level-headed, shrewd? For generations the Haeghemans had run a shell-shop. They were completely accepted in the town. There had of course been that Englishman, who had just about been tolerated in the 'Ostend clan', but now here was his son James ignoring the clan entirely and keeping himself to himself.

As well as his tendency to be inward-looking, which was fostered by his isolated life, it may well have been his preference for the filtered light of his studio-bedrooms that led him to turn away from the Plein-Air style of the Impressionists and their studies of fleeting nuances and surface iridescence. After all, the light on the Belgian coast was no less transparent and shimmering than on the coast of Normandy, which was indeed on the same latitude — and yet that was one of the cradles of Impressionism.

All the same Ensor did feel the urge to paint light a little later, apparently after getting to know the work of Turner, who was of course a brilliant painter of light. It was certainly not pure coincidence that both Ensor and Vogels were influenced by Turner at the same time. We know that they were on a friendly footing at this time, as witness Ensor's portrait of Vogels. Walter Vanbeselaere wonders: 'Might they not both have visited London together, most probably in 1886 or 1887? It must have been at about this

54

time that Ensor became familiar with Turner's work, or rather with the work he produced when he was painting his insubstantial symphonies in ochre, and, near the end of his life, his series of luminous *fêtes galantes* set on the Venice canals. At any rate his first encounter with Turner's work left an unforgettable impression on Ensor.' We can go along with Vanbeselaere when he says that Ensor noticed in Turner's paintings

... the progressive detachment of his vision, which is closely related to his 'method of reproducing reality', and observed how he caught the very essence of the impressions produced by reality in a series of independent pictorial creations... Not only did Ensor encounter in Turner's work an imaginary universe related to the one whose confines he had himself been exploring for so many years, he also found a range of luminous colours seventy-five years older than those used by the French Impressionists. He was going to be able to use these to depict his visions of his own imaginary world.

In this way Ensor was able to shake off for ever the bonds of Realism and make the decisive leap that still separated him from true creative freedom. Turner's influence is at its most immediate and obvious in two of Ensor's paintings dating from 1887 — *Adam and Eve driven out of Paradise* (*Adam et Eve chassés du Paradis*) and a small masterpiece called *Beach Carnival* (*Carnaval sur la plage*).

But not all Ensor's paintings at this stage of his career were based on the study of light-effects. His warm attitude towards other people, which was ultimately to become the moving spirit behind his creative activity, as the fantastic images of his subconscious gradually broke loose, was initially expressed most directly in his depiction of lonely figures weighed down with grief or suffering. Examples here are *Sick Tramp Trying to Get Warm* (*Pouilleux indisposé se chauffant*), 1882; another painting from the same year called *Lady in Distress*; *The Drunkards*, which is full of an everyday realism worthy of Courbet when he shared the socialist ideals of his friend Proudhon; and also the powerful and pitiful figure of the one-eyed *Oarsman* (1883). In an attempt to depict the moving condition of his subjects with greater intensity Ensor returned in this group of paintings to the deep tones of the 'dark' palette he had used in previous years. Ten or so years later he once again felt the need to put in every little detail in order to make the presence of

two elderly *Melancholy Fishwives* (*Poissardes mélancoliques*) in a bedroom haunted by skeletons seem more real. This painting dates from 1892, when his greatest period was drawing to a close.

The year 1883 saw an increasing number of signs that Ensor's genius was flowering, whereas up to then he had merely shown precocious and exceptional talent as a painter. This early talent would probably have been enough to allow him to be the dominant figure in his period, but it was not enough to satisfy his own anxious and demanding character. We can see how he exercised his mischievous imagination on his own appearance in his *Portrait of Ensor in a Flowered Hat* (*Portrait d'Ensor au chapeu fleuri*) (which incidentally is also decorated with feathers). He may have got the idea for this from a reproduction of one of Rembrandt's self-portraits 'in disguise'. But another canvas painted at almost the same time represents the first appearance of the mask that was later to become the most important feature in Ensorian mythology.

An Isolated and Misunderstood Painter

In spite of the enthusiasm he put into his experiments and the exceptionally high quality and originality of his paintings, indeed probably because of their originality, Ensor did not manage to make his presence felt as a painter or to carve out a career for himself. We have already seen how his fellow-citizens in Ostend despised him and for many years his attempts to join in the artistic life of Belgium brought him nothing but disappointments. At that period the only way in which an artist could make himself known and interest both the general public and art-loving critics was to take part in the Salons organized by artists' associations or art clubs. He had therefore attempted to fall in with this scheme of things, but his fellow-artists and the critics in Brussels or Antwerp proved to be no more understanding than the good burghers of Ostend.

In the early stages of his career he had shown one of his earliest canvases, *The Colourist*, at the Salon held by the 'Chrysalide' group in 1881. This association enjoyed the support of the art-loving public and organized exhibitions of avant-garde art in cabarets in Brussels. Shortly after this he again took part in an exhibition organized by 'L'Essor', an art club founded in Brussels to defend Realism, but in 1883 the club rejected his *Woman Eating Oysters*. Before this most of the paintings he had sent to other Salons had also been rejected. The following paintings were rejected one after the other: *Afternoon in Ostend, The Dark Lady*, two still-lifes — *Cabbage (Le Chou)* and *Oysters (Les Huîtres)* — and shortly afterwards *Scandalized Masks (Les Masques scandalisés)* and *Chinoiseries* suffered the same fate.

André de Ridder draws up 'the balance-sheet of these terrible years' in his monograph on Ensor:

The general public, rudely awakened from their peaceful life, were alarmed and promptly turned away from him; the critics, whose preconceived ideas and safe doctrines were shattered by his work, were hostile; and, what is more, even the fellow-artists at whose side he was struggling were hostile. He put up with all that. He may well have suffered from these snubs, but he never resigned himself to accepting them passively, still less to the idea of giving up the task he had undertaken.

This explains why

... in 1883 we find him becoming one of the founders of the Les XX group. A few painters, almost all of them former

59

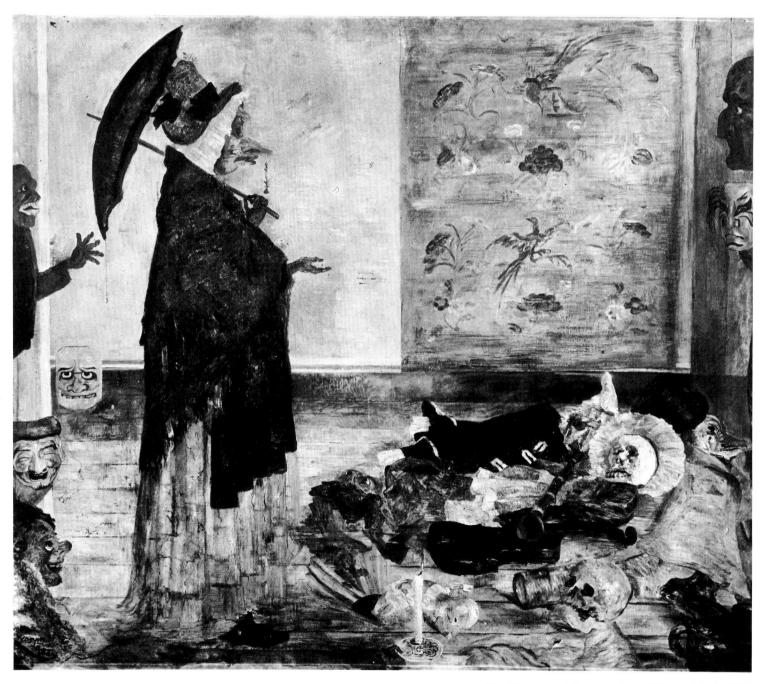

43 *The Astonishment of the Wouse Mask* 1889

members of the 'Essor' group, were so tired of the tyranny and insults they had been experiencing that they decided to form a free group that would warmly welcome independent and innovatory artists. Needless to say Ensor, who had grown used to seeing the doors of the official and non-official Salons closed against him, joined the new group with the greatest enthusiasm, hoping that his honour would thus be avenged. He brought to his membership his splendidly combative instinct and his genius as a painter. But even within this group it wasn't roses all the way, any more than it was when he joined the Libre Esthétique, which emerged in 1894 as a result of the reorganization of 'Les XX'. The new society was run by Octave Maus, who had become its dictator after being secretary of the old group. Maus was an enterprising and eclectic man, but although he did not by any means look down on Ensor, he does not appear to have appreciated the exceptional qualities of the new recruit. The group held exhibitions for a period of twenty-one years, but Ensor took part in only twelve of them and he was often subjected to humiliating reviews, even in those advanced circles. In 1888 a cabale stirred up by his fellow-artists forced him to remove all the paintings he had sent to Les XX, although they had already been listed in the catalogue. This group of paintings just happened to include the following masterpieces: *Adam and Eve Driven out of Paradise, The Temptation of St Anthony* [*La Tentation de Saint-Antoine*], *Children Dressing* [*Les Enfants à la toilette*], *Old Piece of Furniture* [*Vieux Meuble*], *Roofs* and so on. Then in 1890 the paintings he had sent in just scraped through with a majority of one vote (allegedly his own), in spite of the fact that they included *The Astonishment of the Wouse Mask* [*L'Etonnement du masque wouse*], *The Rebel Angels Struck Down* [*Foudroiement des anges rebelles*] and *Masks Faced with Death* [*Masques devant la Mort*], among others.

In 1904 the Libre Esthétique restricted one of their Salons to 'innovators', but only one Belgian painter — the insignificant Théo van Rysselberghe — was invited to show his work alongside the élite of the French Impressionist and neo-Impressionist schools. Surely Ensor would have stood comparison with these so-called 'innovators', many of whom are now completely out of the running?

The snubs Ensor received probably had a lasting effect on his ultra-sensitive character. He still remembered them when he was an old man and was enjoying great if belated fame. In his writings and speeches he liked to exercise his lively and biting wit at the expense of his former rivals, whom he saw as 'anxious, hostile, scowling and full of hatred'.

Lack of recognition had made him turn in on himself and lead a lonely life in which his originality soon flowered. 'I have joyfully shut myself up in the solitary atmosphere dominated by a mask that is full of violence, light and brilliance.' And indeed a stroke of brilliance was to mark his final break with officially approved painting and to shatter the very foundations of painting in his age with a violent crash. In 1888, at the age of twenty-eight, he painted his great revolutionary work, *The Entry of Christ into Brussels*, which was rejected by Les XX in the following year.

overleaf 44 *The Rebel Angels Struck Down* 1889

61

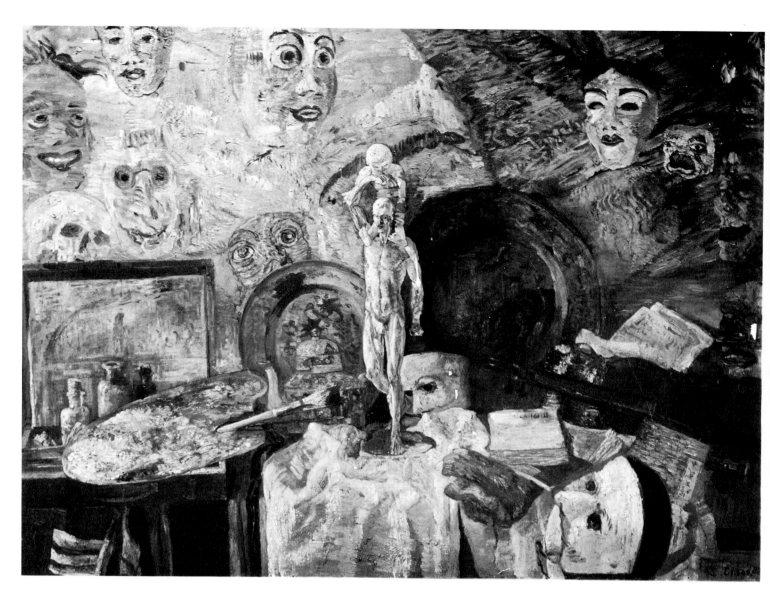

45 *Studio Props* 1889
(detail on page 119)

46 *Consoling Virgin* 1892

64

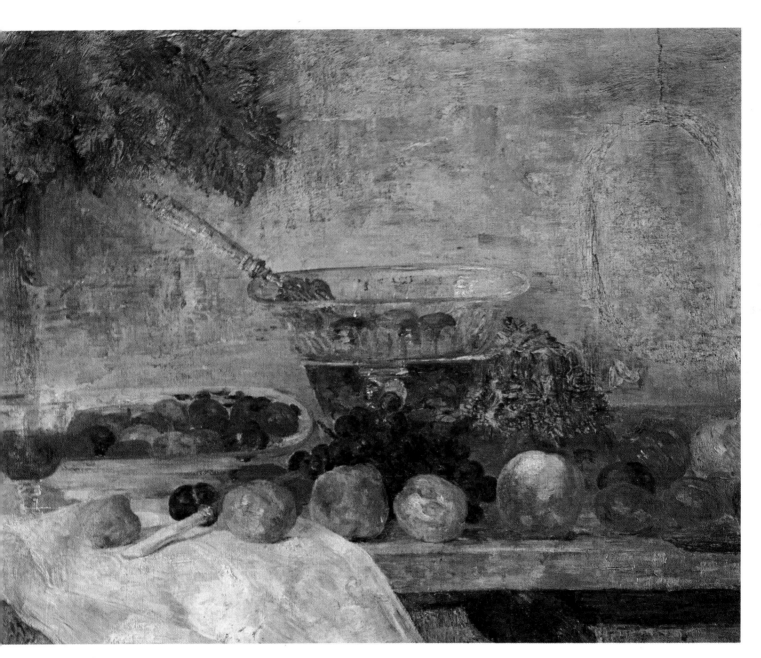

47 *Still-life with Fruit* 1889

The Intellectual and Social Climate of Belgium in the 1880s

It may be easier to understand Ensor's development if we take into account the cultural, social, economic and political events that occurred during his lifetime.

Ever since the mid-nineteenth century new intellectual currents had been circulating in Europe, overthrowing many acquired habits, and the new Belgian nation had had its share of this type of change. For some time the Belgians followed the model of France, which was then undergoing a period of great prosperity in all spheres related to the intellect or to taste. We have already seen that in the field of painting the Realist example of a number of French artists, particularly Courbet, whose *Stonebreakers* (*Les Casseurs de pierres*) had been shown in Brussels in 1851 and had caused a great stir, had encouraged some Belgian painters to break away from the conventional rules of Classicism. It had also tempered some of the excesses of Romanticism before the influence of the Impressionists extended the range of this new freedom — a freedom, incidentally, which was often more a matter of technique than of creative imagination. We have also seen how Ensor had asserted his independence in this respect.

At this same period other equally important events were taking place in areas that probably did not affect him as directly, though he did not remain completely indifferent to them. For instance, a dual literary movement had rapidly developed. One strand involved work written in French, while the other was formed by Flemish-speaking writers, the two separate strands corresponding to the dualism between the Walloon and Flemish races and the bilingual problem that divided the population of Belgium into two camps. The fact that French literature was enriched at this period by the work of a number of Belgian writers, from both Flemish and Walloon backgrounds, was not solely the result of a deliberate policy of Gallicization. The main reason was that the middle classes in Flanders preferred to use French because it was a sign of education and breeding, whereas the various Flemish dialects were spoken chiefly by the working classes and the peasants. French was the language used in all sectors of the teaching profession. It was spoken, for instance, in the elementary schools, and in religious establishments such as the secondary school that Ensor went to as a boy, and even at the university of Ghent,

66

48 The cover of the special issue of *La Plume* devoted to Ensor 1898

where virtually all lectures and classes were held in French down to 1923, and at the Catholic University of Louvain in Brabant.

So it is hardly surprising that although Belgium was enjoying a renaissance of Flemish literature at this period, Flanders also produced a number of talented authors writing in French. The precursors of the Flemish renaissance were the historical novelist Hendrik Conscience and the mystical poet Guido Gezelle. It was subsequently confirmed by the younger generation of writers attached to *Van Nu en Strake*, a journal founded in Brussels in 1893 by a group of avant-garde Flemish writers with European leanings. Among other French-language writers of the same period were Maurice Maeterlinck, who was in fact a student at the University of Ghent, and the poet Emile Verhaeren, author of *Villes tentaculaires* and *Toute la Flandre*. Verhaeren was a friend of Ensor's and was one of the first people to speak out in his defence.

But the fame of Maeterlinck and Verhaeren, which was recognized in France at a very early date, was to eclipse somewhat the reputation of many other French-speaking Belgian writers, though not necessarily inside Belgium. The first to suffer was an older writer, Camille Lemonnier, the author of powerful Naturalist novels who in 1883 had even been dubbed 'Marshal of Belgian letters' by his younger colleagues on the journal *La Jeune Belgique*. For a long time Ensor refused to forgive Lemonnier because he preferred the work of Emile Claus, who had become the Luminist painter of the banks of the river Lys, after his discovery of the Impressionist canvases of Claude Monet. On the other hand another Belgian novelist, Eugène Demolder, committed himself wholeheartedly to supporting Ensor in his art criticism, and was the first person to devote a monograph to him. This was published in Paris as early as 1889, and subsequently in Brussels in 1892. Verhaeren's book *James Ensor* was not published until 1908. Apart from the sections of the special issue of the Paris journal *La Plume* that the Symbolists devoted to Ensor in 1898 these were virtually the only gestures of support that he received from his contemporaries in literary circles.

The last twenty years of the nineteenth century were marked by a thorough-going change in the social climate. From 1830 to that time, the new subjects of King Leopold I, who was a popular figure in spite of his authoritarian views, avoided party political strife and instead remained faithful to 'unionism', while stagnating in a rather petty fashion in their provincial existence. Although this state of affairs suited the middle and upper classes pretty well, the lot of ordinary working people, condemned to a life of illiteracy and poverty, was hardly an enviable one.

But this situation could not continue indefinitely. Soon agricultural progress in the form of the rationalization of crop-growing and cattle-breeding had been achieved; more important still, industry had developed rapidly and very considerably once the machine age got under way (though this did not put a stop to the exploitation of the proletariat).

The social consequences of these economic changes were not slow to appear. Moreover, they fitted in with the general trend of ideas in Belgium at that date. Quite apart from the leanings of some intellectuals towards the 'romantic' socialism of 1848, a small trade union of weavers had been set up in Ghent as early as 1857, and by 1866 sectors of the working population in Ghent, Brussels and Verviers had joined the first International. But it was not until after 1867, when Marx's *Das Kapital* was published, and as a result of the dissemination of Marxist theories at the annual Congress of the International Workmen's Association held in Brussels the following year, that the Belgian Workers' Party (*Parti Ouvrier Belge*) was set up, in 1885. This new party offered a new political force, Social Democracy, to fight the Catholics and Liberals, who had up to now shared power and the running of the country between them. The struggle to improve the material situation of the working class had begun. It was to make itself felt in a long series of social disturbances, strikes and harsh repression.

The extreme poverty of the working classes produced partisan reactions in the world of letters and the arts, as we can see in some of the Naturalistic novels written by Camille Lemonnier or Georges Eekhoud, and in the inspiration behind the work of the sculptor Constantin Meunier, whose invariable subject was the work performed by miners, dockers and agricultural labourers, and their sufferings. Then several collections of poems by Emile Verhaeren show how strongly this impassioned writer was moved by the social and humanitarian preoccupations of his age, though he in fact favoured a form of socialism that was more generous and idealistic than doctrinaire. It is probable that Ensor shared the democratic sentiments of his poet friend at the same period, though they were associated in his mind with images of the Christian legend that were still alive in the popular heart of Flanders. After all, it is surely right to interpret *The Entry of Christ into Brussels*, the huge composition he painted in 1888, at the height of the class struggle that followed the setting up of the *Parti Ouvrier*, as an allegorical illustration of the popular revolt.

49 *Portrait of Emile Verhaeren* 1890

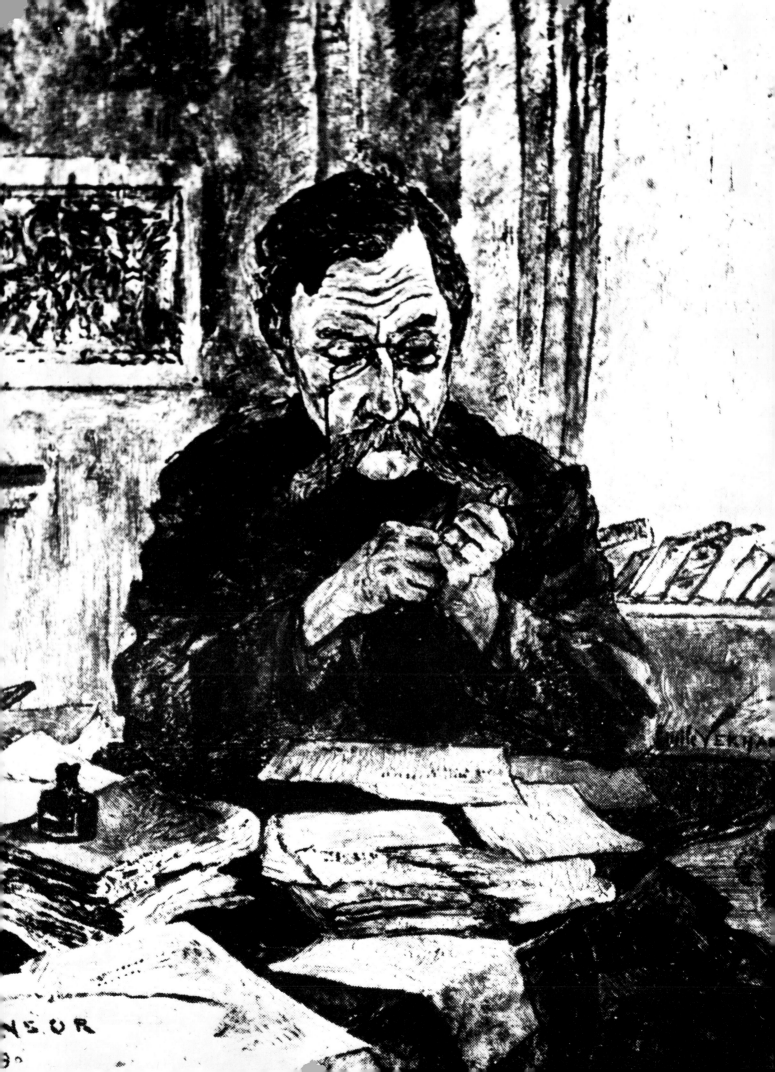

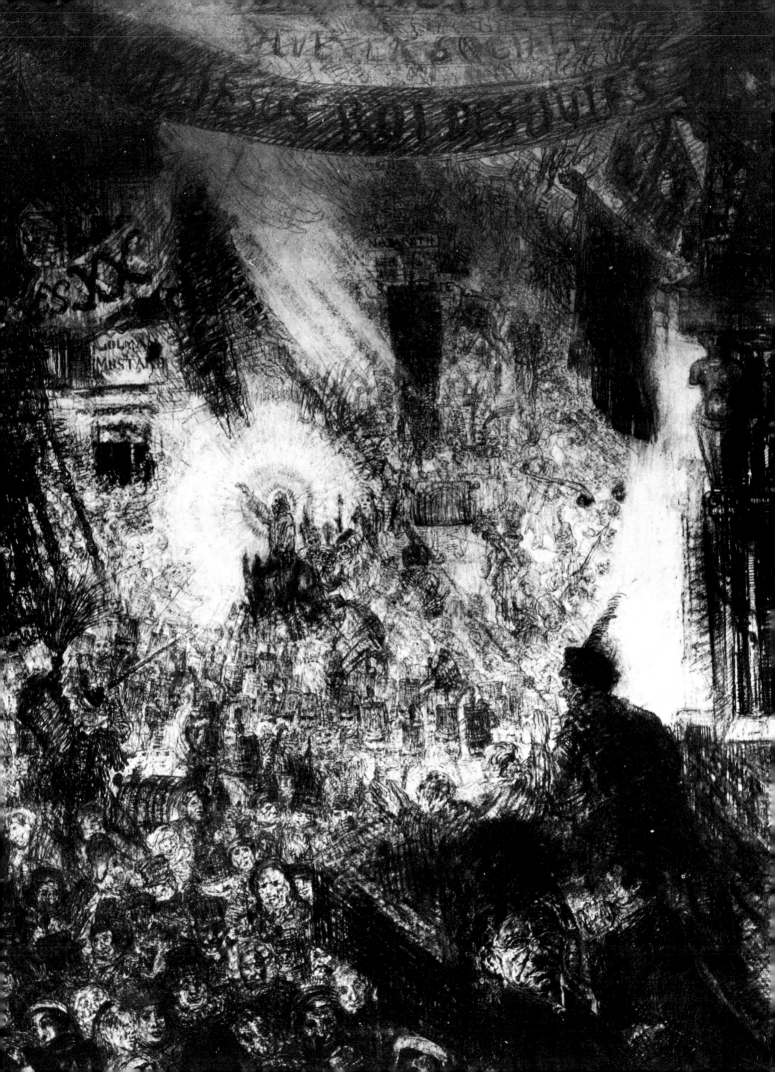

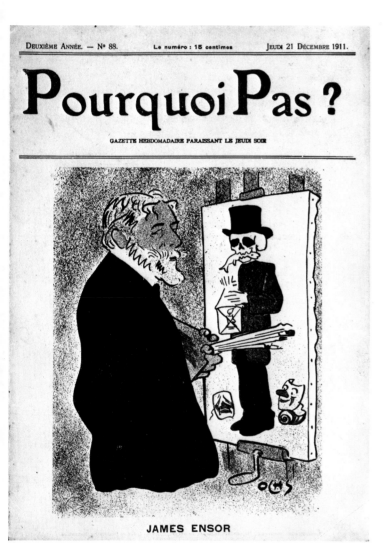

DEUXIÈME ANNÉE. — N° 88. Le numéro : 15 centimes JEUDI 21 DÉCEMBRE 1911.

Pourquoi Pas ?

GAZETTE HEBDOMADAIRE PARAISSANT LE JEUDI SOIR

JAMES ENSOR

51 Cover of the weekly journal *Pourquoi Pas?* 1911

50 *The Lively and Radiant Entry into Jerusalem* 1885

on the following pages

52 *The Entry of Christ into Brussels* 1888

53 *The Entry of Christ into Brussels* (detail)

Whatever the purpose behind this work, it would be wrong to put too much emphasis on Ensor's temporary political commitment when he was painting *The Entry of Christ into Brussels*. The painting represents the tragi-comic swelling tide of a carnival crowd in which all the different characters involved in the human tragedy rub shoulders together. A long frieze painted diagonally across the top part of the composition bears the following proclamation in huge capital letters: 'VIVE LA SOCIALE' ('LONG LIVE THE SOCIALIST STATE'), while banners waving above the crowd are daubed with other inscriptions that are more closely related to the painting's subject — ('Long Live Jesus King of Brussels' — or a more whimsical one that reads 'Doctrinal fanfares are always successful'. In the engraving he produced ten years later, in 1898, Ensor modified several details in the original painting and the streamer labelled 'VIVE LA SOCIALE' disappeared, though he increased the number of other mottoes and slogans. This time he didn't hesitate to write 'Long Live Anseele and Jesus', thus linking the name of one of the founders of the Parti Socialiste Belge with that of Christ. He again repeated 'Long Live Jesus King of Brussels', and 'Doctrinal fanfares' was complemented by the slogan 'Phalanx shattering Wagner', while other banners and signboards announce 'The Pork-butchers of Jerusalem' or 'Grateful Samaria' or even 'The FLEMISH Movement' and 'Les XX', which recalls his tricky dealings with that artistic circle.

Ensor's behaviour had always included a strong dose of irony and aggression. This had driven him in his youth to join with a medical student who was a friend of his in lampooning publicly a Brussels pork-butcher 'who they didn't like the look of', or the doyen of the critics, a man called Fétis, whom Ensor saw as his persecutor because he hadn't thought much of the work he had sent to the Les XX Salon. This is how the weekly *Pourquoi pas?* later described the incident: 'The two friends positioned themselves in the Place du Musée and when M. Fétis came out of the Library they rushed towards him, pulling the most hideous faces. Ensor thumbed his nose at him and Dr R— embarked on an extremely lifelike imitation of a pig grunting. According to Ensor, this represented "devils

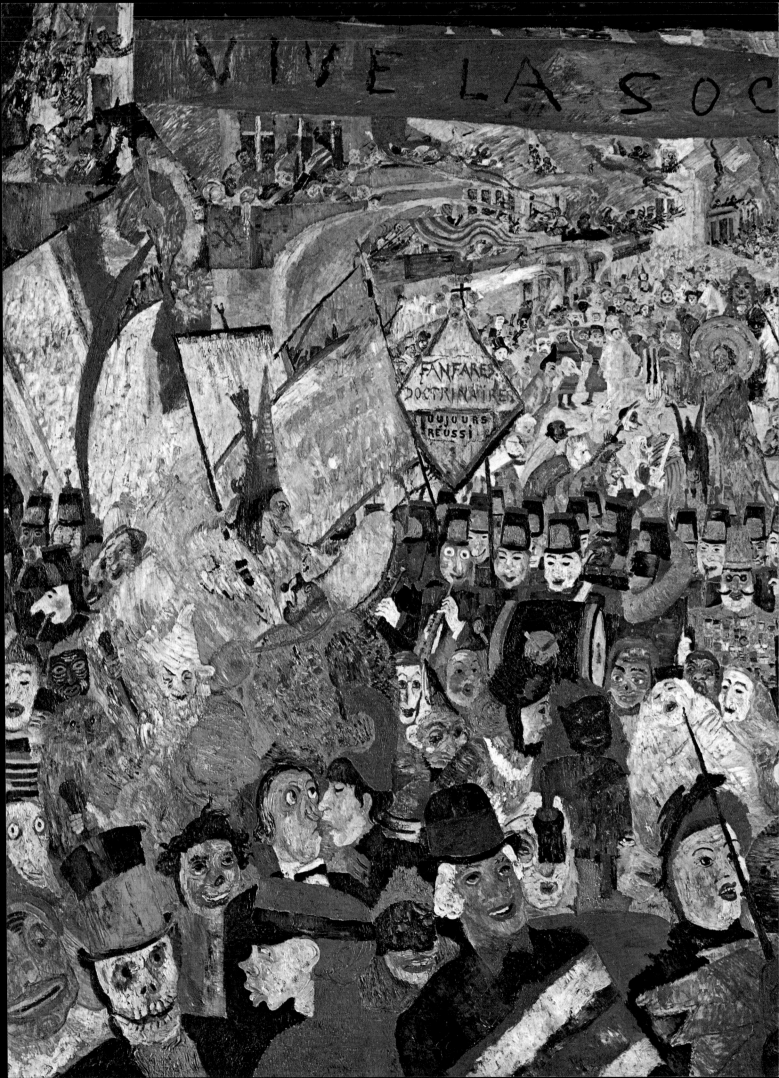

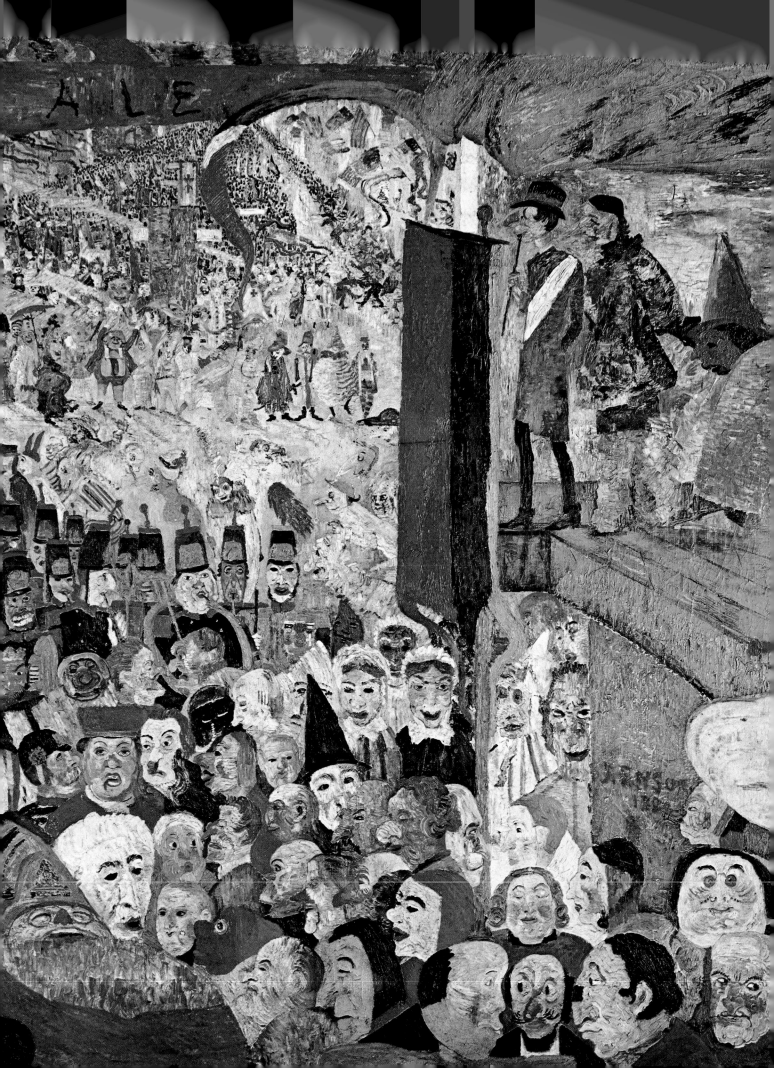

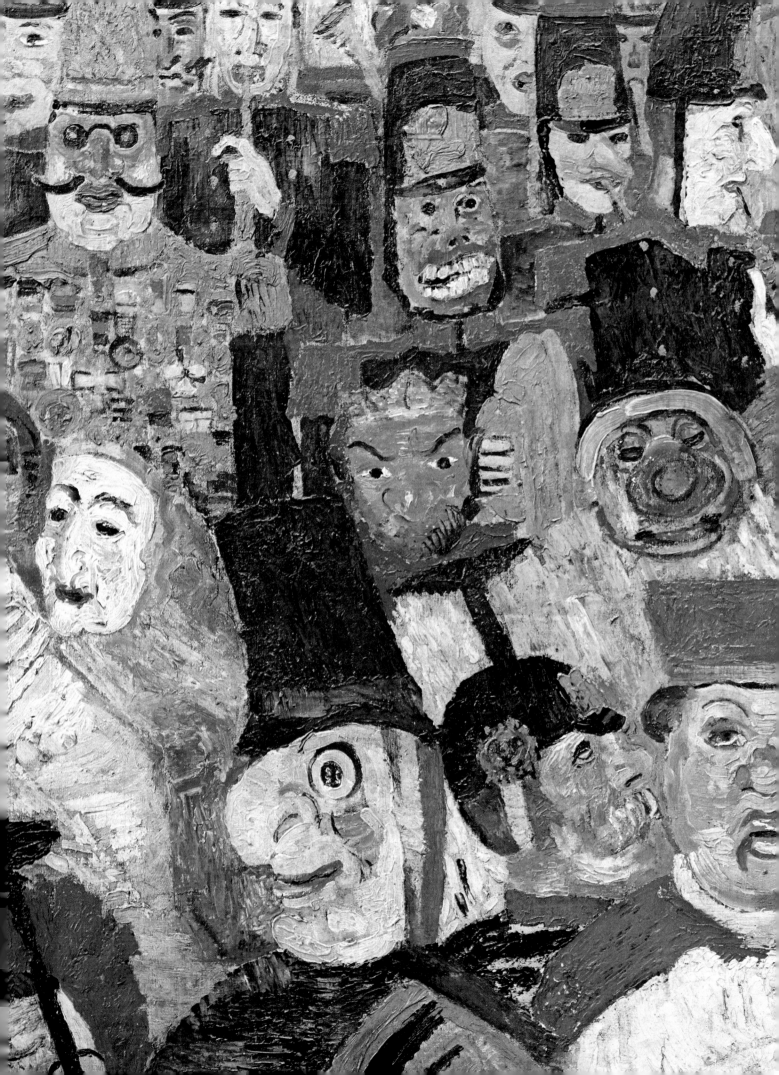

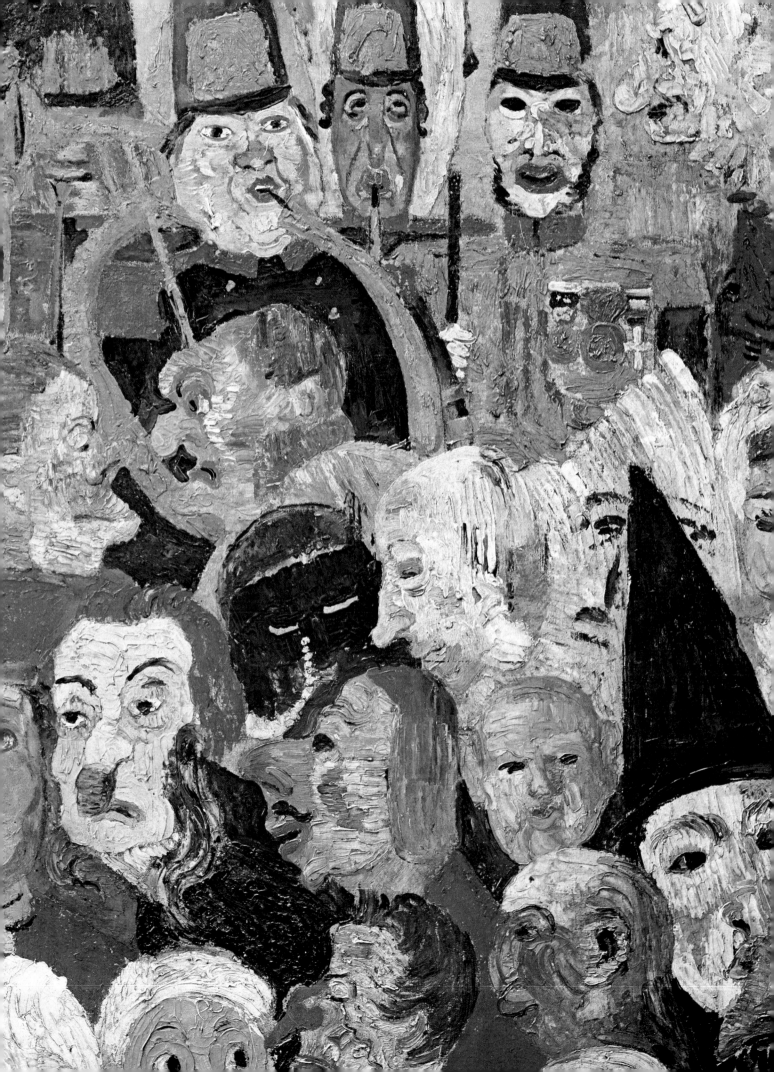

playing the buffoon with a critic." Ensor was evidently a fairly gay dog in his time.

But its significance as a political manifesto is far from being the only important aspect of *The Entry of Christ into Brussels*, that 'fighting and eternal piece of work', as André de Ridder has so rightly called it. He has also left us a very vivid description of this large canvas:

[It is] strangely filled with hundreds of figures, some of whom seem to be emerging from the frame and walking towards us, laughing and arrogant, while others, prompted by their feeling of revolt or stimulated by love, are grouped in tiers round the minute yet dominating figure of Christ the Redeemer, radiant amid the standards and challenging slogans, the musical instruments and fairground trestles, in all that crush of a delirious throng of workmen, politicians, mountebanks and musicians.

The extraordinary three-dimensional qualities Ensor achieved in this unusual canvas, and the pictorial revolution he initiated are far more important than any social significance he could attribute to it. After all, its effectiveness as a 'social action' could never be authenticated because it didn't leave the painter's studio. It was not seen by the general public until it was exhibited for the first time in 1929, at the large retrospective exhibition of Ensor's work held at the Palais des Beaux-Arts in Brussels.

From the pictorial point of view there are a number of striking differences between *The Entry of Christ into Brussels* and all Ensor's previous paintings. These differences even suggest that there was a distinct break in his development, which had so far followed a coherent and continuous pattern. Yet although he was shaking off the bonds that had so far linked him to a specific tradition, he held firmly to the skills and technique he had acquired, adapting them to a completely different type of expression. This applies, for instance, to his gifts as a colourist. Whereas previously, in *Woman Eating Oysters,* he had lightened his palette in an attempt to give a more accurate rendering of light and to retain nothing but the vibrant lightness that indeed appears to have been the actual subject of *Children Dressing* (1886) and particularly of *Beach Carnival* and *Adam and Eve driven out of Paradise* (1887) — he did in fact actually refer to this large canvas as a 'Study of light' — in *The Entry of Christ into Brussels* he clearly developed

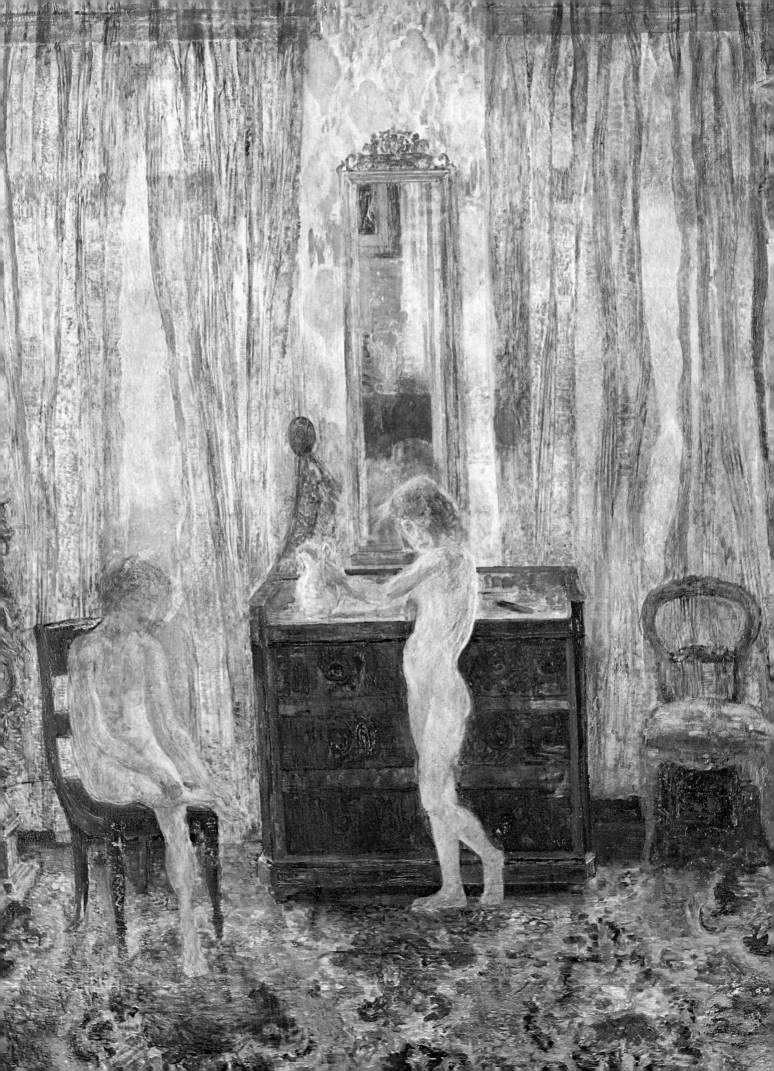

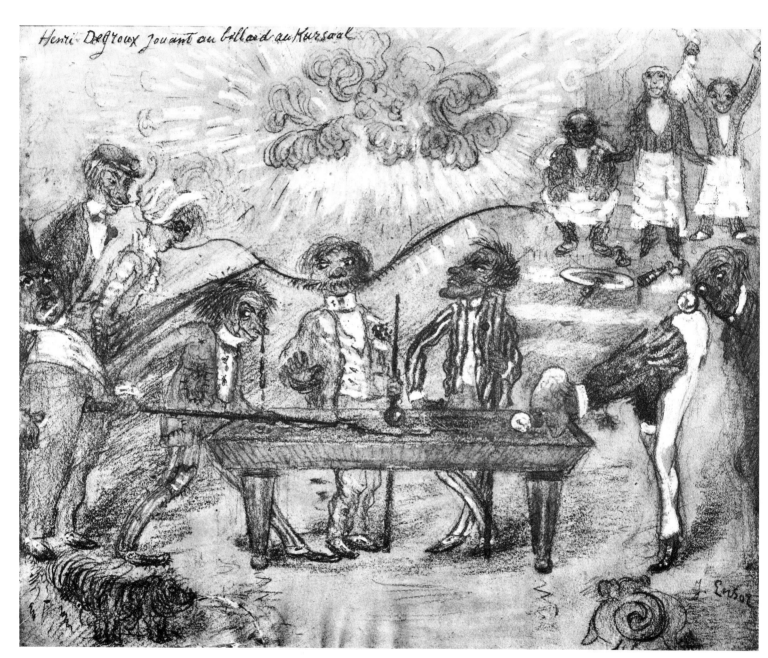

55 *Henri de Groux at the Billiard Table* 1907

a completely different sense of his expression of pure colour.
M. Vanbeselaere offers a good explanation of this highly
important development: '*The Entry of Christ* not only
represents the greatest triumph for Ensor's luminous palette,
it also represents, and indeed this is its chief importance,
the transformation of light and full colouring into a whole
series of shrill and discordant chords, which are coarse and
brutal, yet genuinely exciting. With them he was able to
demonstrate his own highly imaginary and personal view of
the world of masks, in which men's feelings are deliberately
and freely laid bare.'

Relying on the expressive properties of colour, he has
created an amazing pictorial fanfare made up of the most
brilliant colours to match the teeming carnival-like throng.
But the effects of time on the coloured pigments have
probably toned down the discords, and the canvas we see
today seems much more harmonious than it must have been
when his contemporaries saw this fighting work as a
fairground painting.

Incidentally, for a long time this key work received
nothing but disparaging comments. One example is the
following by the art-historian Grégoire Le Roy, in his
important work on Ensor (Brussels: G. Van Oest 1922),
written when the painter's reputation was well established:
'Even paintings such as *The Entry of Christ into Brussels*, in
which the artist pushes the purity of his colours and the
prime importance of the draughtsmanship to the limits of
paroxysm and even paradox, deserve something more than
amused curiosity. It is no coincidence that he used the same
colours and the same naïve stylization as in the stereotyped
coloured pictures handed out to children. He may have been
mistaken; it may be that this type of ultra-improvised
expression, this type of highly intellectualized art, does
not come within the realm of Beauty.' And M. Le Roy then
concedes that the least we can say is that we can sense
that he was anticipating various attempts, which were not
as successful but were applied on a more strictly theoretical
basis, to adopt Cubism and some of its derivatives.'
This comparison does indicate some confusion on the
part of the author about the various movements in
modern art.

In his insistence on the dynamism of pure colour, and on

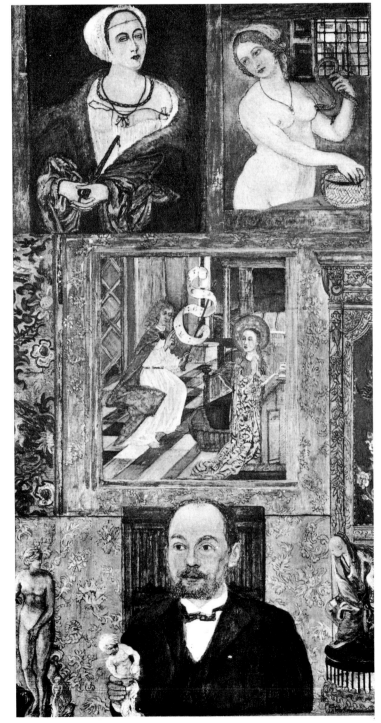

the simplicity of shapes reduced to their diagrammatic components, Ensor may perhaps merely have been searching for the stylistic effectiveness of a popular method of expression adapted to suit a piece of work improvised for a special occasion. He may not have planned to bring about a more far-reaching pictorial revolution both from the technical and aesthetic points of view. Never a theoretician, he not only failed to formulate his intentions or the principles underlying his new style, he never drew the consequences of his discovery, for he did not exploit it on a systematic basis in his later work, or attempt to encourage others to adopt it. The subsequent development of his work confirmed that he refused to repeat himself and to take advantage of his successive victories from one canvas to the other.

The importance of the bold steps he took in planning and executing *The Entry of Christ* as an example for others to follow did not make itself felt until after the German Expressionists, and subsequently their Flemish counterparts, had begun to recognize him as a precursor. Yet we can admit today that in its own day this revolutionary work of Ensor's already — in 1888 — represented a break with the past that was no less radical and no less important in its effects than another painting-cum-manifesto painted twenty years later, in 1907 — Picasso's celebrated canvas *Les Demoiselles d'Avignon.*

Whether or not he appreciated at the time the full innovatory implications of his new form of pictorial expression, Ensor remained very attached to *The Entry of Christ into Brussels* and refused to be parted from it. When he did eventually agree to let a rich Antwerp collector have it — he had already bought a large number of Ensor's paintings and longed to add this huge composition to his collection — he stipulated that he should retain a life-interest in it. As a result, in old age he was able to keep his masterpiece within sight — hanging on the walls in his studio-cum-drawing-room in his house in the Rue de Flandre.

Ensor's Engravings

An artist less enterprising and less prolific than Ensor at this date would have needed a year to paint a canvas as richly detailed and as huge (101 $^5/_{16}$ x 149 $^1/_4$ in., 2.58 x 4.31m) as *The Entry of Christ into Brussels*. In 1888 Ensor not only produced several other fairly important paintings, such as *The Garden of Love* (*Jardin d'Amour*) and *Masks and Death* (*La Mort et les masques*), he also executed a very large number of engravings — more than a third of his total output in fact.

This figure is given in the summary or Ensor's activities as an engraver drawn up by Louis Lebeer, Curator of the Print Room at the Bibliothèque Royale in Brussels. In his monograph *James Ensor aquafortiste* * he gives the following detailed list:

Altogether James Ensor executed with his own hands 133 engravings, made up as follows: 117 etchings, 14 drypoints, 1 soft-ground etching and 1 lithograph. His first attempt at engraving came in 1886, when he produced 8 plates at one sitting. In 1887 he published 11 and in 1888 — the year when he painted *The Entry of Christ into Brussels* — he produced no less than 45. From that time onwards his hectic activity in the field of engraving gradually slowed down. Up to 1904 the Master of Ostend was to sign only 2 or 3 plates a year, if that, and he was eventually to abandon his burin completely...

When the whole of Ensor's output as an engraver was put on show at the big retrospective held at the Musée National d'Art Moderne in Paris, an expert as sensitive as the French art historian Jean Cassou stated firmly that Ensor's engravings were 'comparable to Rembrandt's'.

Ensor's output of engravings, to which he devoted only a very small amount of his time, cannot match that of Rembrandt, which includes about three hundred plates. But the technical mastery and creative originality he displayed in this medium are as impressive as Rembrandt's. The comparison seems doubly justified when we remember that we have here two of the world's greatest painters, who were just as successful in working in black and white, in engravings, as they were in handling paint brushes and colours; also, both of them showed a preference for the same technique — etching, plus drypoint on some occasions.

* No. 5 in the fifth series of *Monographies de l'art belge*, published by the Ministry of Education and De Sikkel (Antwerp 1952).

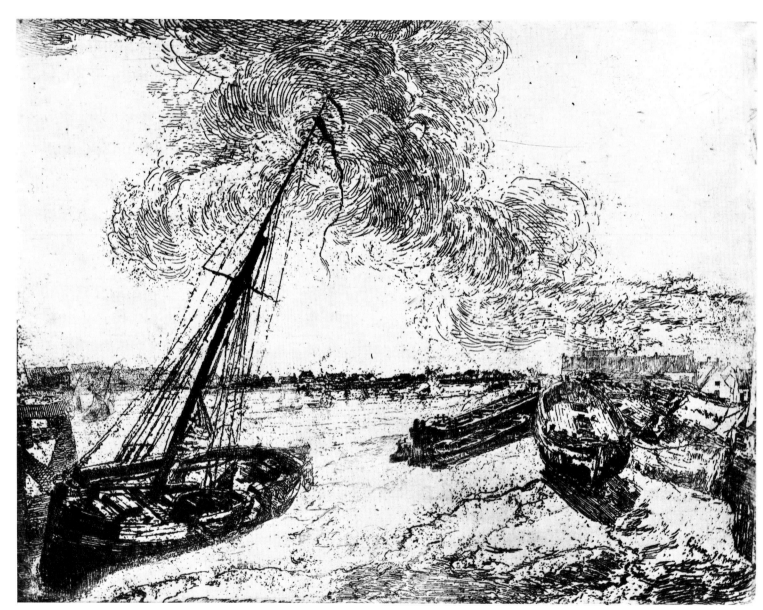

57 *Boats Stranded on the Beach* 1888

58 *Sick Tramp Trying to Get Warm* 1895

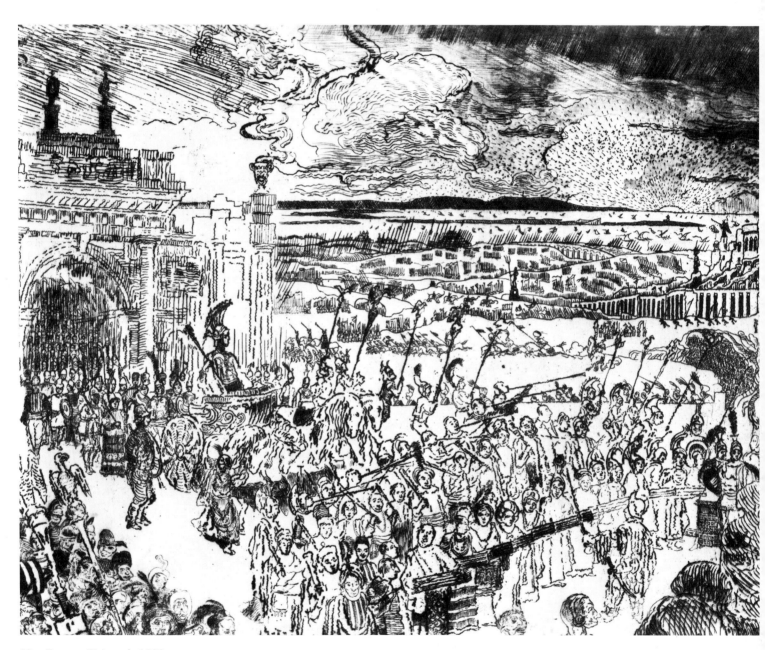

59 *Roman Triumph* 1889

60 *Death Pursuing a Flock of People* 1896

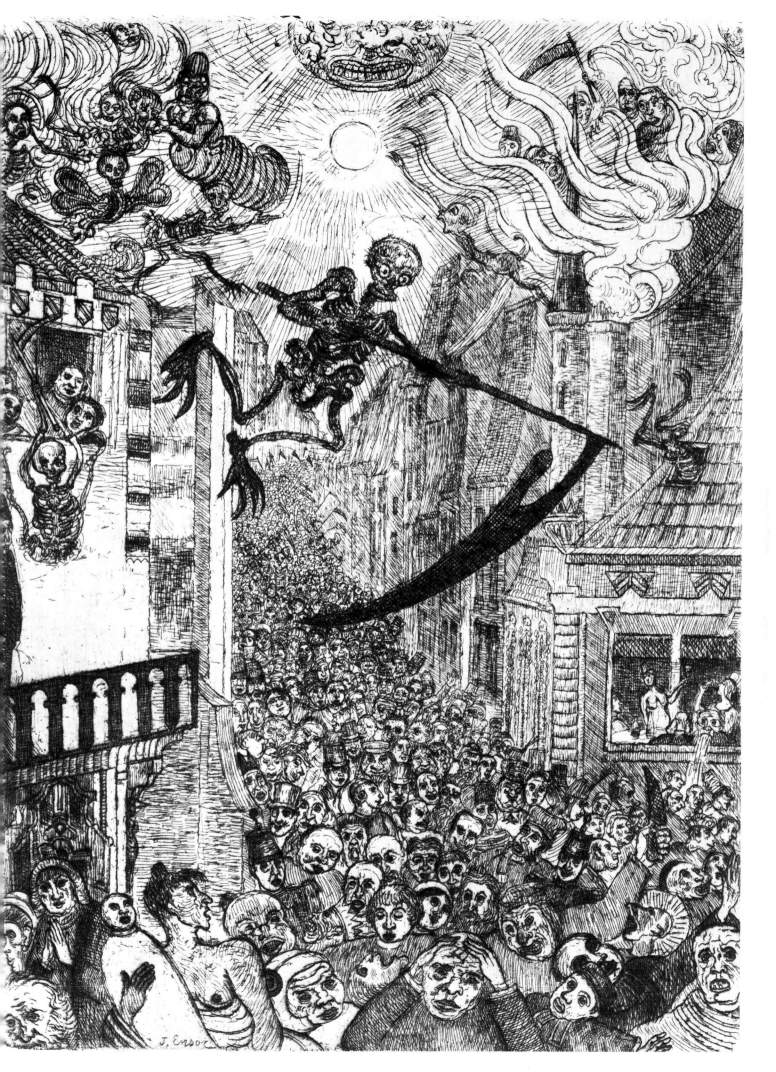

Louis Lebeer offers an excellent account of the important contribution made by Ensor's engravings to his over-all creative output:

We might have thought that James Ensor's vision automatically involved subtle modifications to his palette; we might have imagined that his method of depicting light could not possibly be achieved without the shuddering interplay of his colours; but his etchings and drypoints prove that he needed only a few lines, or even a few dots, to reveal the very essence of that light and its effect on bodies and objects, on a scene viewed through eyes that are capable of spiritualizing its content, and stripping it of everything except the elements that make it come alive when light is focused on it; that these few lines were enough to allow him to communicate to us his dream-like visions. When James Ensor paints he is clearly carried away by the magic of his colours; but when he engraves he can no longer see — even with his painter's eye — anything but lines, and in a wider sense the properties of black and white that are essentially the province of the eyes of the mind.

And Lebeer goes in even greater detail into the close links between Ensor's engravings and his paintings, into what we might call their over-all unity:

Ensor's etchings and drypoints are a very important feature of his *oeuvre* as a whole. Not only by virtue of their beauty and originality, but also because on more than one occasion they complement and define the unique qualities of the vision in a large number of his paintings, or even of the way they were executed. Although some of their themes were taken up again, sometimes several years after they'd been engraved, in one canvas or another, Ensor would also be inspired by some of his etchings to turn them into paintings — again several years later. In doing so he would adhere faithfully to the same vision that inspired the engraving. This represents a terrible obstacle for those who have struggled to work out not so much a chronology as a logical and coherent line of development running through his output and his changing styles: dark style, light style and so on.

A few examples serve to illustrate these transpositions from one technique to another:

The drypoint depicting *Christ Calming the Storm*, dating from 1886, was the prototype for paintings produced first in 1890, then in 1891; *Boats Stranded on the Beach*, engraved in 1888, did not inspire the artist's paintbrush until 1900, and *The Gamblers*, which was etched on copper in 1893, was not transferred on to canvas until 1902. Conversely, *The Entry of Christ into Brussels*, painted in 1888, was turned into an etching in 1898, and *Tramp Trying to Get Warm*, a painting dating from 1882,

61 *The Gendarmes* 1888

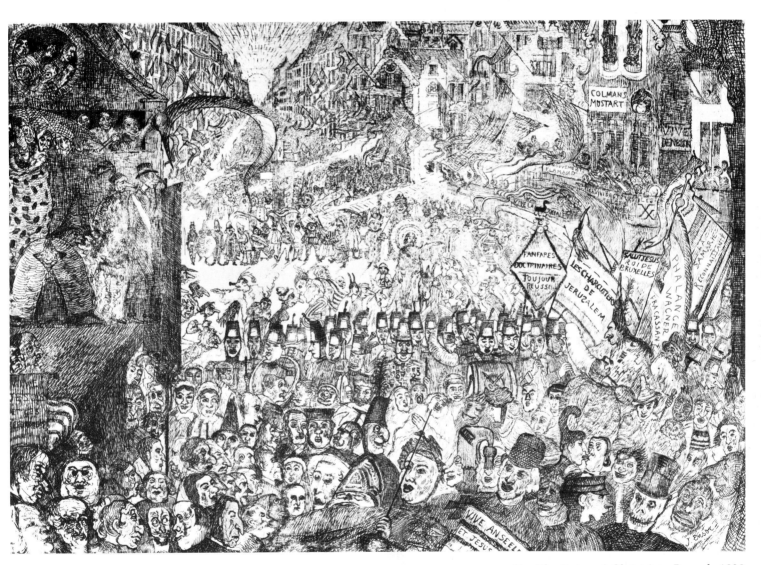

63 *The Entry of Christ into Brussels* 1898

62 *Portrait of Ernest Rousseau* 1887

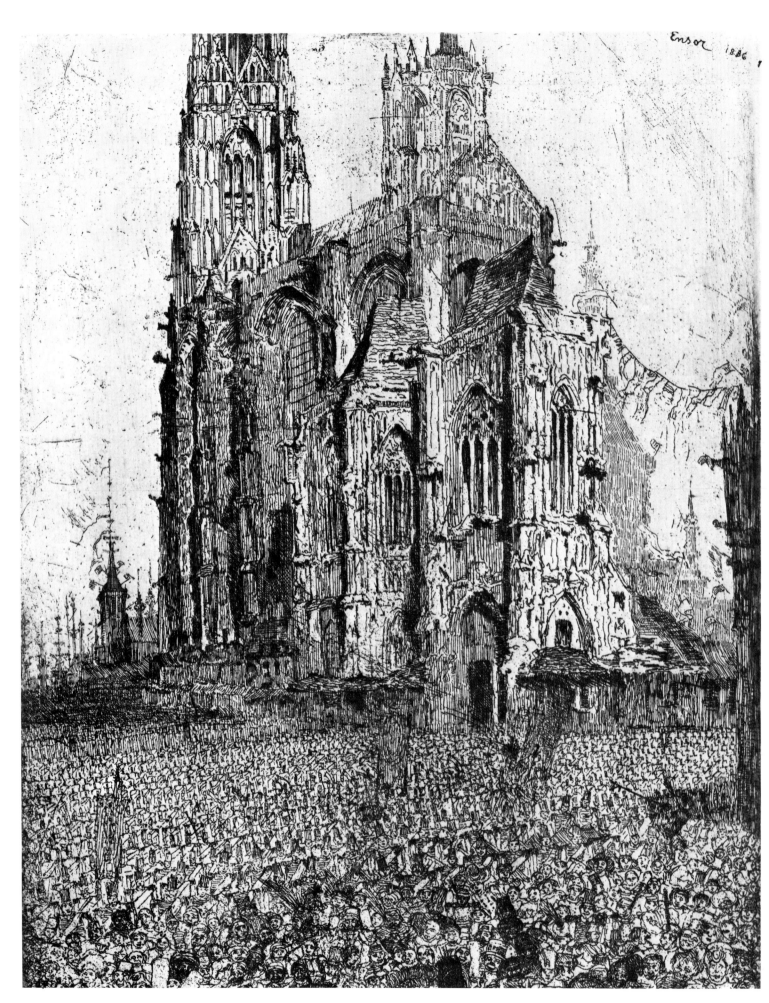

was not used as a subject for an etching until 1893, while another canvas in the same vein, *Scandalized Masks*, painted in 1883, was not engraved until 1895.

One other point: the engravings based on paintings are easy to pick out because the subject-matter is always reversed on the engravings — Ensor had not taken into account the fact that the engraved plate is reversed when it is printed. On the other hand the paintings that repeat the subject of an engraving are the same way round.

As well as these transpositions from one medium to another, engraving often gave Ensor an opportunity to give a new direction to his pictorial work, or to interpret a theme that did not seem to him to correspond exactly to the painter's requirements or to the specific language of painting. For instance, one of his first etchings, *The Cathedral* (*La Cathédrale*), which dates from 1886 and is one of his masterpieces in this medium, depicts a swarming crowd of masked figures at the foot of a majestic building. He was later to cover virtually the whole canvas of his *Entry of Christ into Brussels* with a similar jostling throng. We might well think that the precision that is an essential feature of all graphic work had helped him to find a way to express the organization of this moving throng in the greatest possible detail even before he put brush to canvas. He enjoyed engraving large groups of people on other occasions — in the plates called *Death Pursuing a Flock of People* (*La Mort poursuivant le troupeau des humains*, 1896), for instance, or *Hop-Frog's Revenge* (*La Vengeance de Hop-Frog*, 1898). Indeed even his very first engraving, *Christ Mocked* (*Le Christ insulté*), executed in 1886, shows him attempting to create a similar bustling crowd.

The freedom in conception and execution that he was able to enjoy in his engravings is once again confirmed by the fact that although he resisted the temptation to adopt some form of Impressionist, Divisionist or Pointillist technique when he was looking for ways of expressing light in his paintings, he did allow himself one or two genuinely 'Impressionist' etchings. Louis Lebeer's careful analysis of these prints leads him to this conclusion. He starts by examining the engraving called *Christ Calming the Storm* (*Christ apaisant la tempête*) and comments:

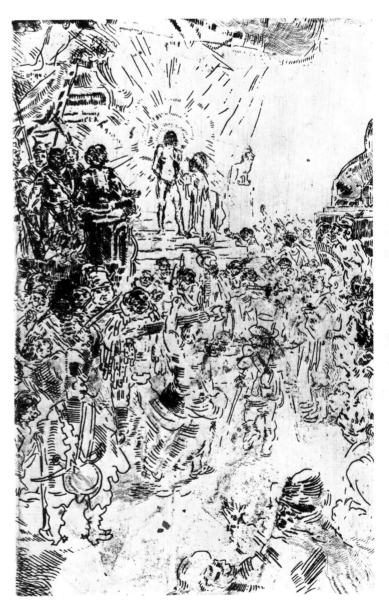

65 *Christ Mocked* 1886

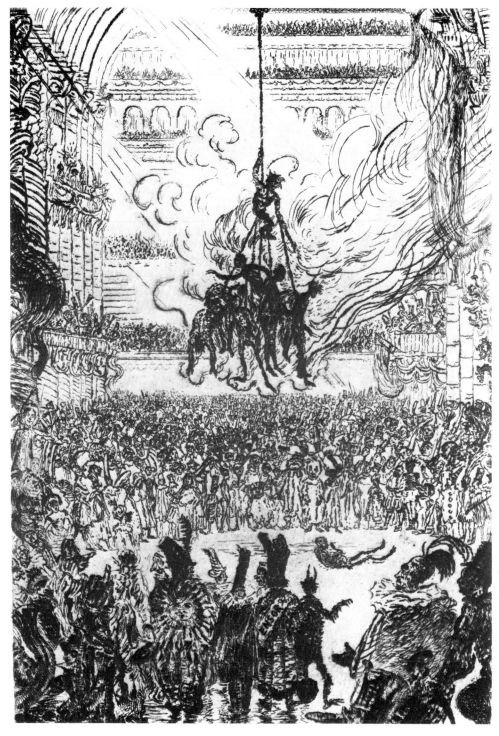

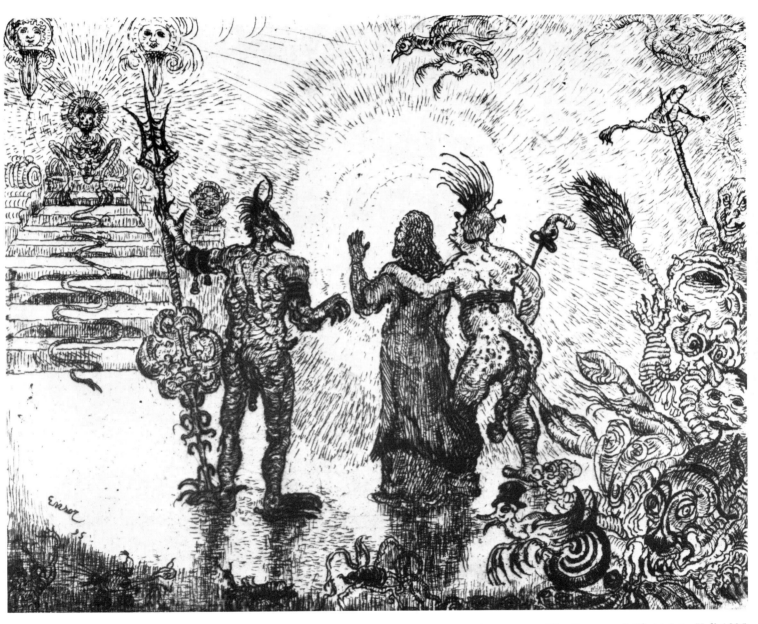

67 *Descent of Christ into Hell* 1895

66 *Hop-Frog's Revenge* 1898

overleaf 68 *Battle of the Golden Spurs* 1895 (detail)

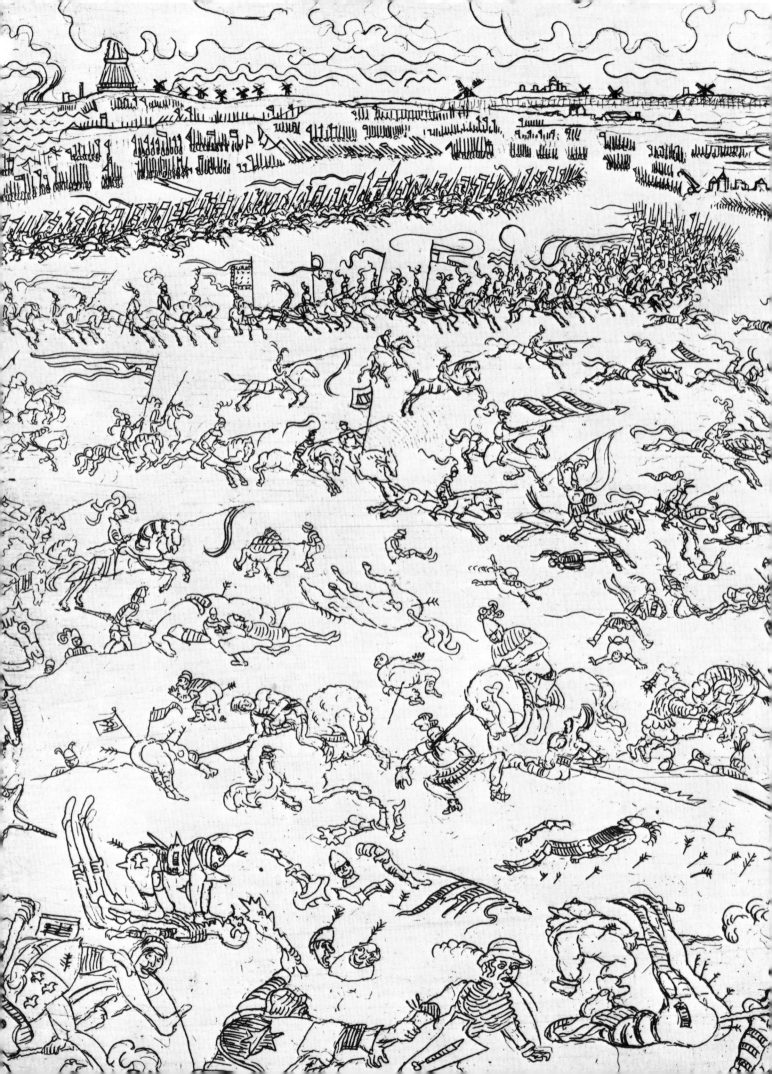

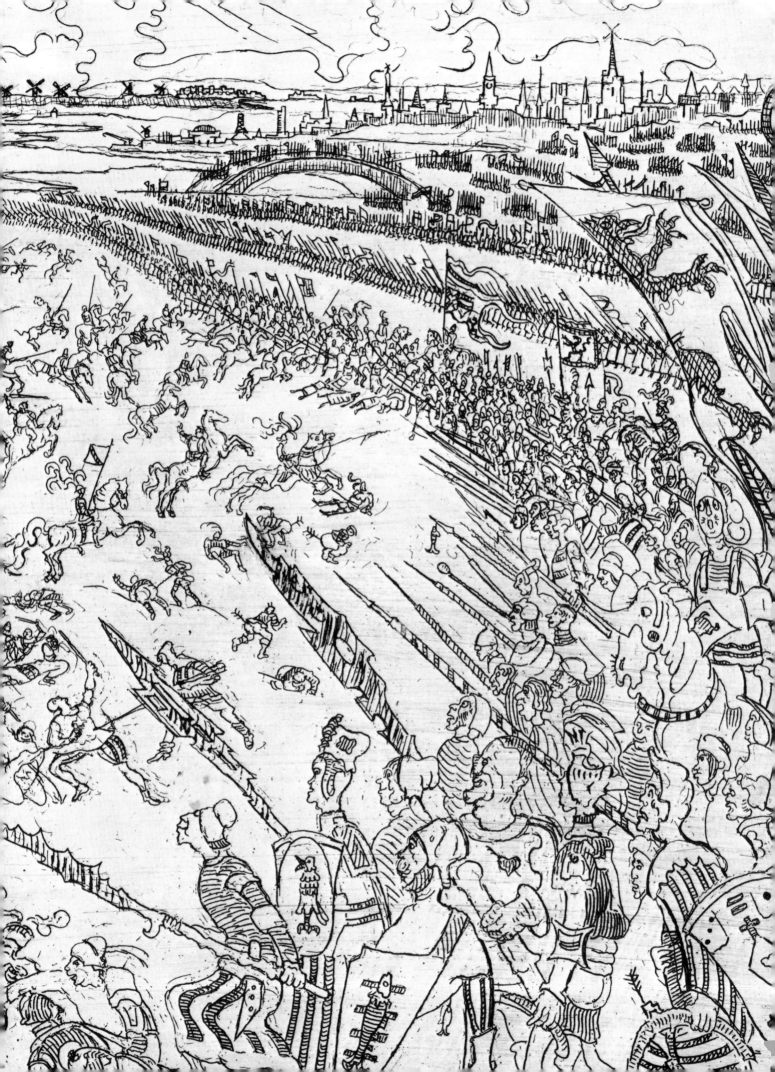

71 *Panoramic View of Mariakerke* 1887

69 *Pond with Poplars* 1889

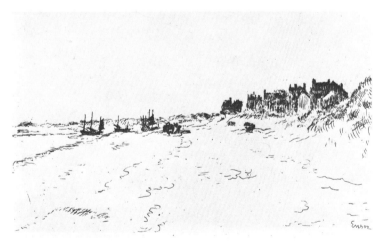

70 *The Beach at La Panne* 1904

It must be judged in its exclusively drypoint state, before it was etched, if we are to appreciate and admire its subtle richness, its sensitive powers, its Impressionist treatment of light. In that state the eye can detect the delicate tonal modulations that can be achieved with lines etched in drypoint, the suggestively transparent notes enlivened by the pure surface of paper that reacts to the way lines are arranged, intertwined and inflected and can thus conjure up an impression of water, air, atmosphere and light all at the same time. In this instance the use of the etching technique betrays the direct subtlety and sustained delicacy of the original composition, but this is clearly not true of those of Ensor's works that started off as etchings.

Leeber then recommends his readers to study two other important engravings: *Panoramic View of Mariakerke* (*La Grande vue de Mariakerke*), 1887, and, even more, *The Large Docks at Ostend* (*Le grand bassin d'Ostende*), 1888, are evidence of this. 'No other work has ever managed to better the latter work in conjuring up, with so few material aids and so deliberately, the play of light trembling and vibrating, breaking up lines and contours yet not destroying them. *This is pure Impressionism.*'

Lebeer's assessment is absolutely accurate. He enlarges on it in the following words: 'This is not analytical Impressionism in which the play of light is revealed in its essential and specific action...', and he stresses the importance of *The Large Docks at Ostend*, in which 'the trembling of the light is rendered by a lifelike swarming throng of tiny lines and dots, following the traces of the lines and contours that make up the lively shapes. It seems like magic when a few lines and dots incite the paper to intensify the light and offer an image of the sky above and an arm of the sea below.' The same kind of Impressionist interpretation of a landscape can also be seen in one of Ensor's last etchings, *The Beach at La Panne* (*La Plage à La Panne*), 1904.

Again, Ensor gave free rein in his engravings to his boldest vein of creative imagination and his most spirited satire. These result in burlesque scenes and caricatured or frankly grotesque figures. We might well think that in such instances he is a worthy rival of Hieronymus Bosch or Breughel, within the Flemish tradition of *diableries*, scenes played out by devils and imps. Yet his compositions in this vein seem to be entirely improvised and absolutely

opposite

72 *Christ in Triumph Surrounded by Masks and Demons* 1895

73 *The Judges* 1891

96

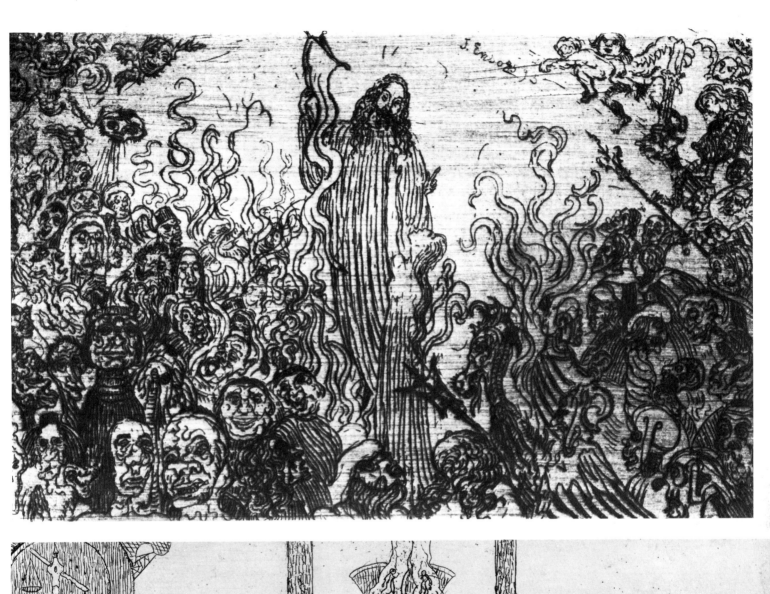

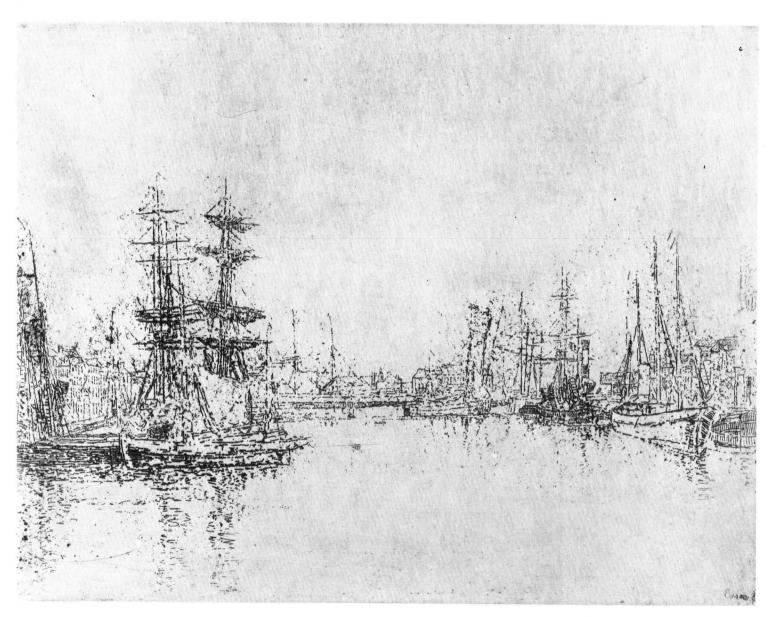

74 *The Large Docks at Ostend* 1888

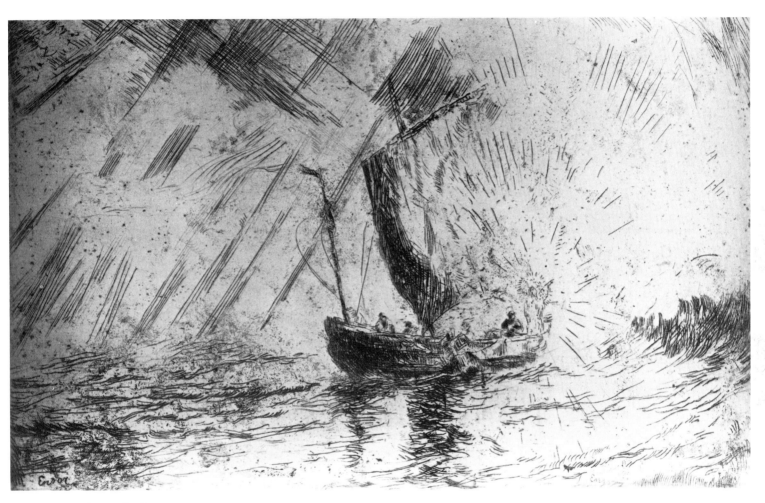

75 *Christ Calming the Storm*

78 *My Portrait in 1960* 1888

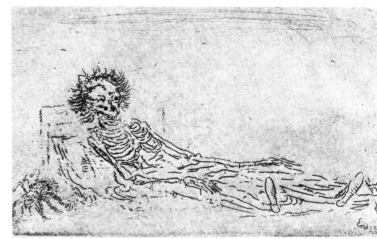

76 *The Skaters*

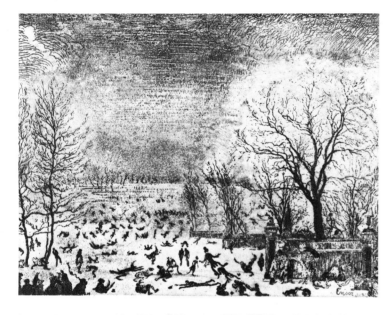

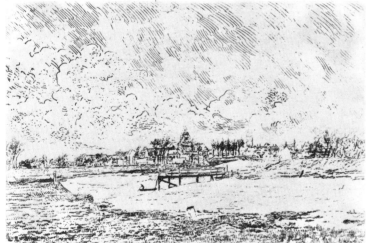

77 *View of Nieuport* (*The Channel at Nieuert*) 1888

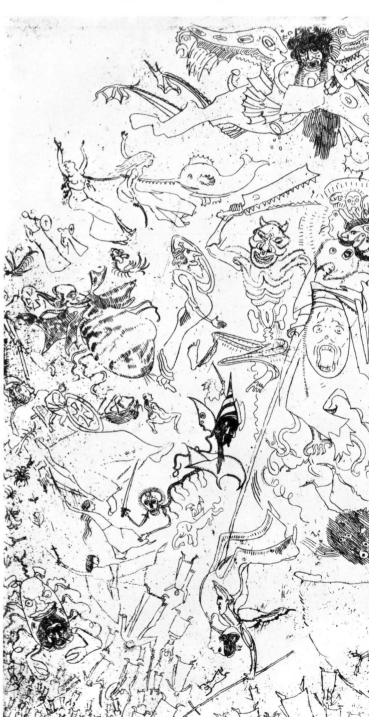

79 *Combat of Demons* 1888

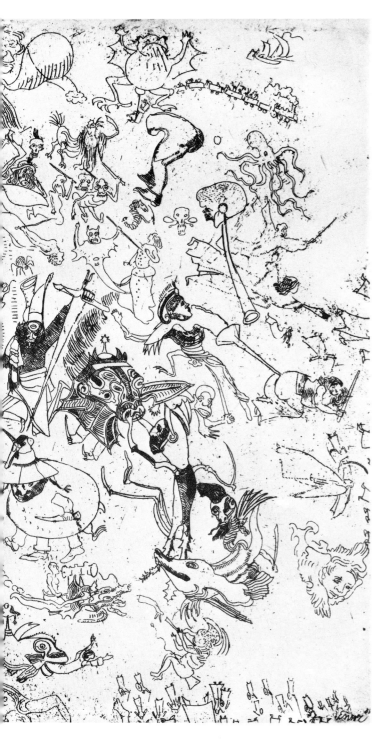

80 *The Orchard*

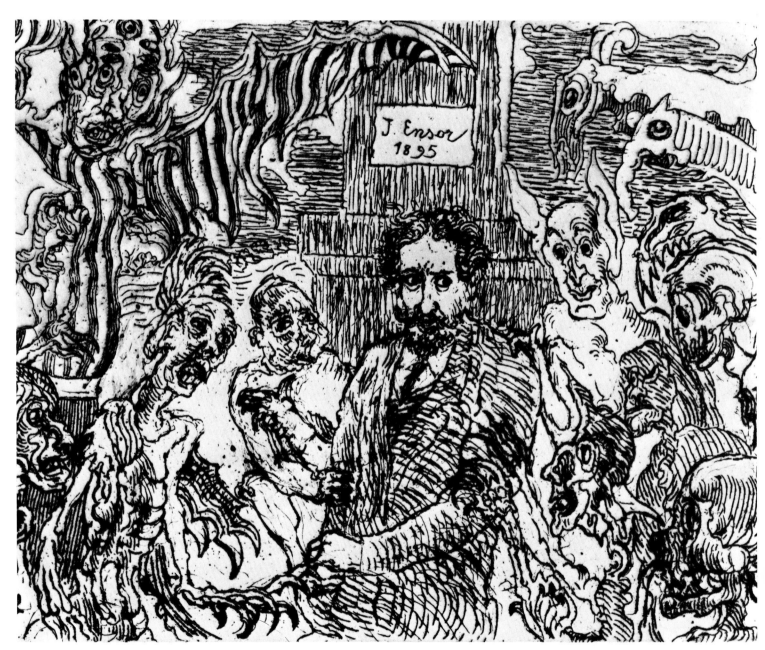

81 *Demons Tormenting Me* 1895

original, because of the imaginative fantasies displayed in them and their spontaneous style. When his burin conjures up diabolical visions he is not trying to repeat the conventional image of the temptation of St Anthony, but to describe his own obsessions in delirious images of *Devils on their way to the Sabbath* (*Diables se rendant au sabbat*), 1887, or *Devils Thrashing Angels and Archangels* (*Diables rossant anges et archanges*), 1888, or even a scatological flight of fancy in *Sorcerers Caught in a Squall* (*Sorciers dans la bourrasque*), 1888. But the most important example of an engraving that brings to life the phantasmagoria conjured up by Ensor's imagination is one in which he depicts himself surrounded by *Demons Torturing Me* (*Démons me turlupinant*), 1895, and thus identifies himself with the figure of *Christ Tormented by Demons* (*Le Christ tourmenté par les démons*), which he engraved the same year.

The variety of subjects he tackled shows the richness and fullness of Ensor's graphic work. For instance we have historical scenes such as *Roman Triumph* (*Triomphe romain*), 1889, and *The Battle of the Golden Spurs* (*La Bataille des éperons d'or*), 1895; ironical or even savage attacks on specific social groups, as in *Gendarmes* (*Les Gendarmes*), 1888, *Good Judges* (*Les bons juges*), 1894, or *Bad Doctors* (*Les mauvais médecins*), 1895; and even illustrations of the work of Edgar Allan Poe, such as *King Plague* (*Le roi Peste*), 1895, or *Hop-Frog's Revenge* (1898). What is more his first success was due to his etchings — as early as 1898 the Paris journal *La Plume* devoted a fully illustrated special issue to his work as an engraver. This was followed by a one-man show of his work at the journal's offices in the Rue Bonaparte in Paris. This homage was made by men of letters who were more interested in the spirit of his work than in its form — this is clear both from the content of the articles in the special issue and from the interest they showed in another Belgian artist, the 'satanic' Symbolist painter Félicien Rops. But this does not lessen the importance of their action in ratifying his success, particularly if we remember that is occurred many years before his talent was recognized in his own country.

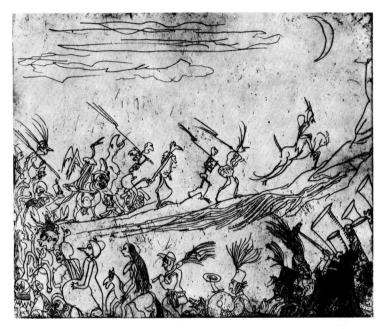

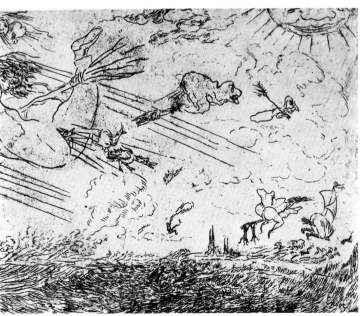

top 82 *Devils on their Way to the Sabbath* 1887

below 83 *Sorcerers Caught in a Squall* (*The Winds*) 1888

103

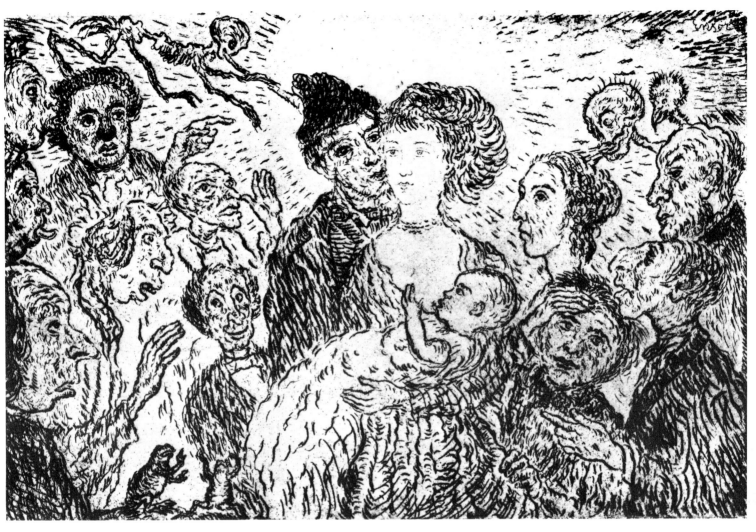

85 *Envy* 1904

86 *In the Street*

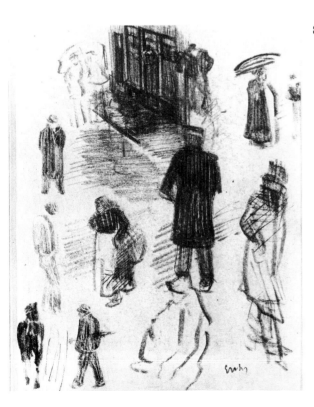

87 *The Street*

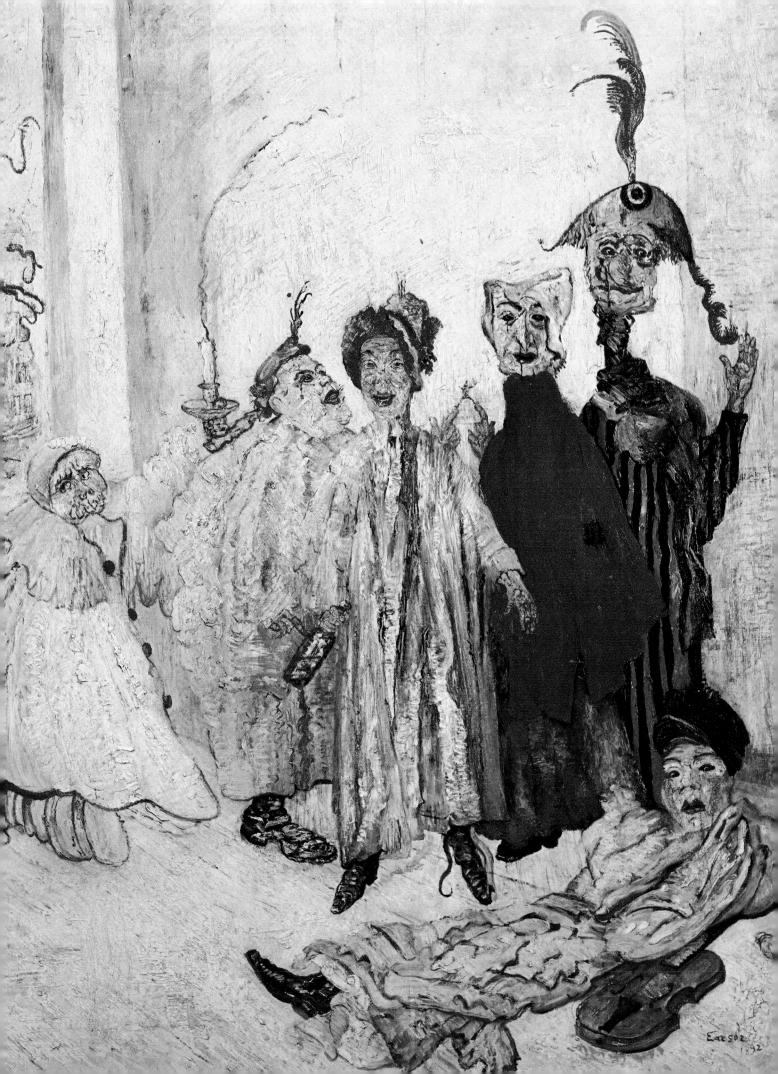

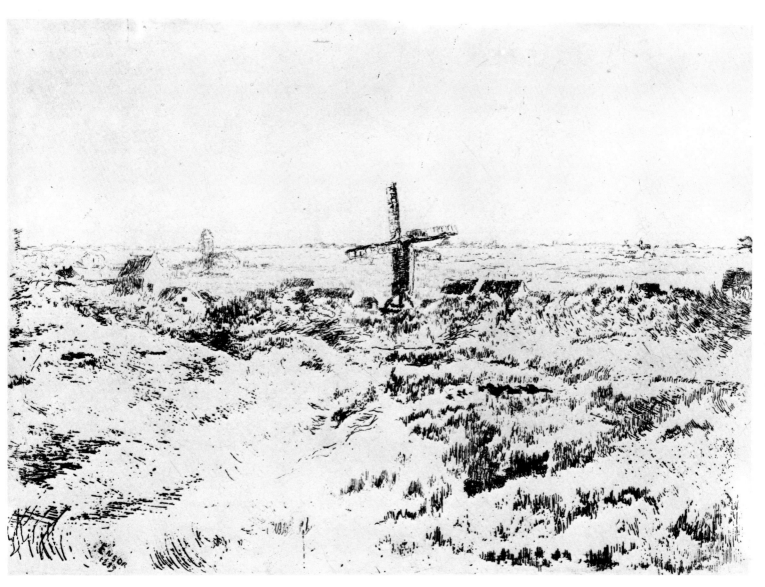

89 *Windmill at Mariakerke* 1889

88 *Strange Masks* 1891

108

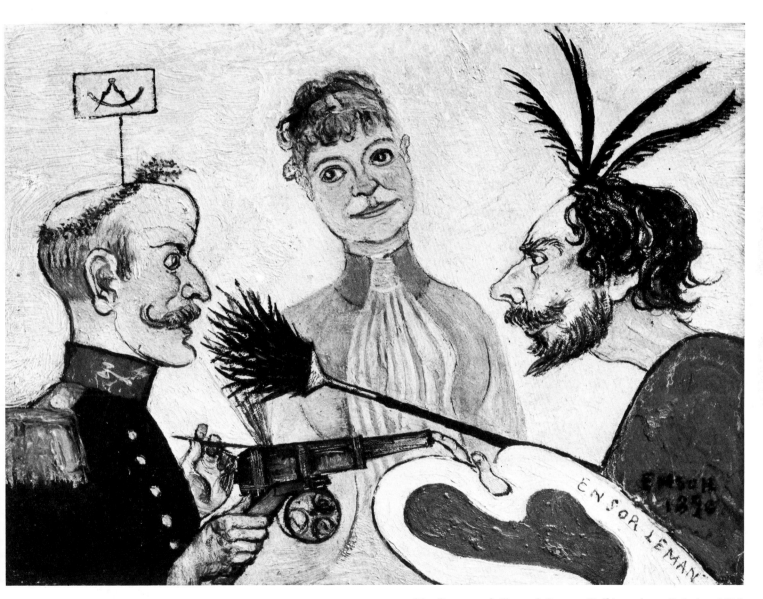

91 *Ensor and General Leman Talking about Painting* 1890

90 *The Germans Enter Ostend* 1940

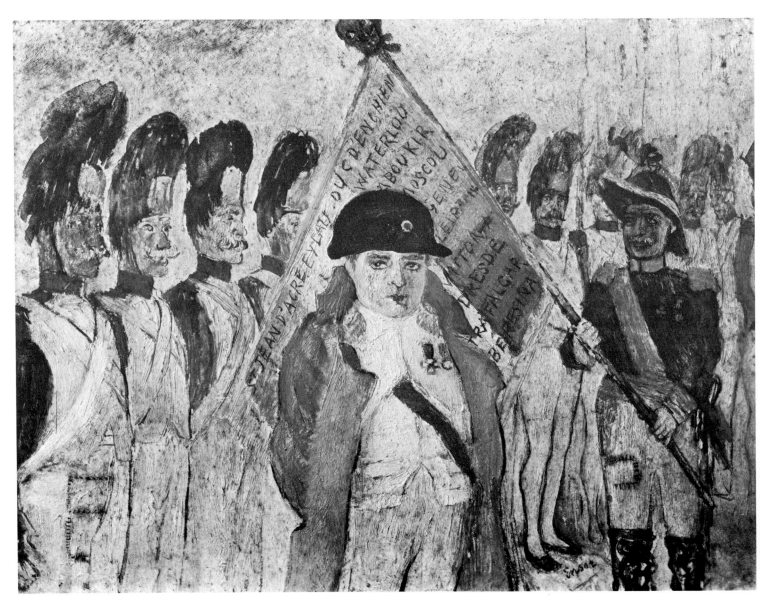

92　*The Remorse of the Corsican Ogre* 1891

Ensor's Greatest Period 1888-92

If we discount one or two small paintings or etchings inspired by Ensor's humanitarian feelings, such as the painting entitled *Gendarmes*, which dates from 1892 and is based on an etching of 1888 depicting strike victims in Ostend, or an allegory called *The Remorse of the Corsican Ogre (Remords de l'Ogre de Corse)* and another called *Philip II in Hell (Philippe II aux enfers)*, the pictorial protest made by *The Entry of Christ into Brussels* is unique in Ensor's *œuvre*. Yet it marked an important turning-point by giving new impetus to his creative powers. His output had slowed down somewhat during the previous two years, after the failures he had experienced in the various Salons, though it was probably these very failures that spurred him on to hit back with this gigantic masquerade.

The prolific period that began at this point and that was to last for only four or five years was dominated by the presence of masks. This feature of Ensor's art is so characteristic that we may be tempted to see the mask as a symbol of his personality when he was at the height of his powers, though in fact his personality is revealed just as skilfully and simultaneously in paintings that belong to various *genres*, in which the element of strangeness is much less obvious, or indeed non-existent.

Great care must be taken in attempting to draw a line between reality and imagination in Ensor's work, particularly when it comes to his predilection for the world of masks. He himself offered the following explanation of this preference:

From 1883 onwards masks had a profound effect on me... With my pursuers close upon my heels I gleefully locked myself up in the solitary land of bantering mirth in which the mask, wholly made up of violence, light and brilliance, holds sway. The mask means to me: freshness of tone, sumptuous décor, large and unexpected gestures, high-pitched expression, exquisite boisterousness.

And he concludes: 'Overcome by irony, moved by such splendours, my vision grows sharper and I purify my colours until they are whole and personal.' We can therefore agree with André de Ridder when he says:

Ensor's masks have a psychological significance and, even more, a plastic significance. A painter is entitled to select purely *overleaf 93 Intrigue 1890* pictorial motifs to pin down an object, a form or a tonality. It is

111

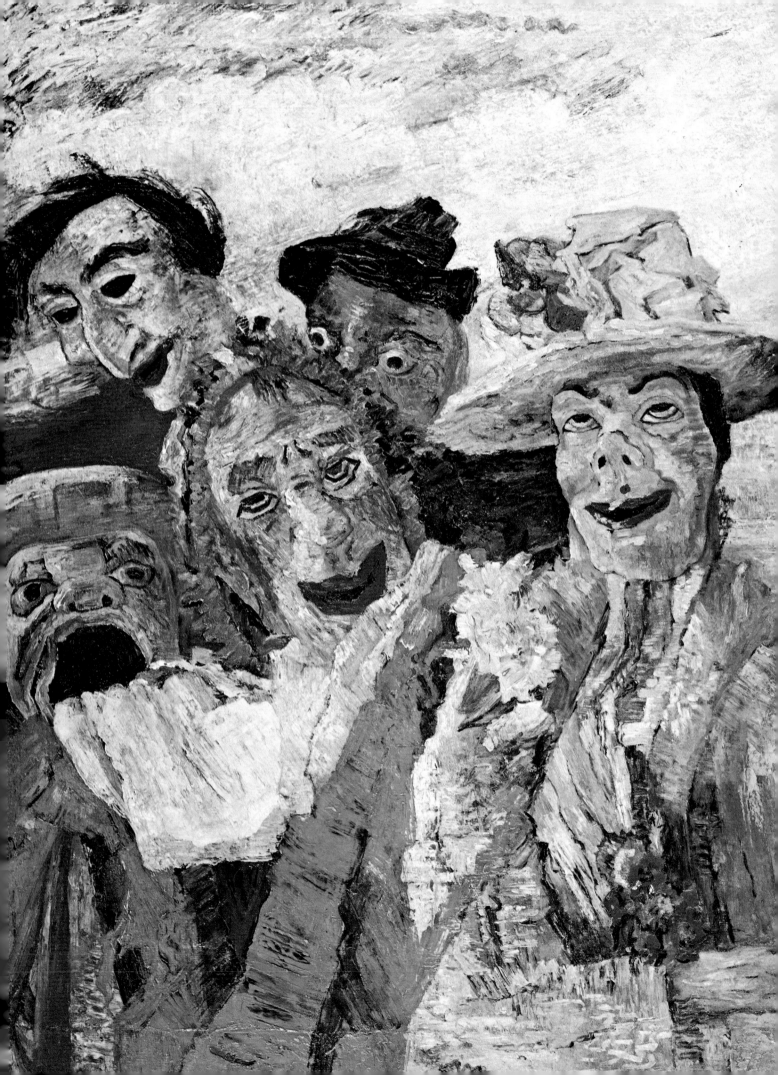

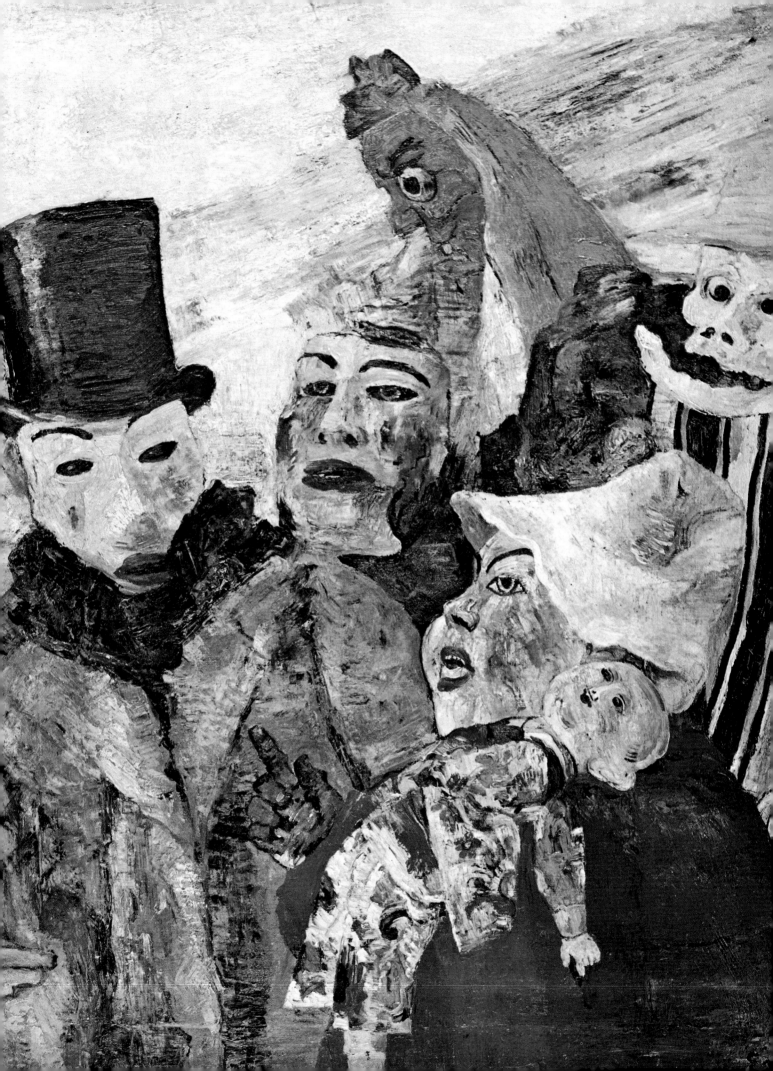

also obvious that Ensor's fondness for masks was based chiefly on what they represent in plastic terms, on their contours, their colours, the direction in which they face. A mask is an inanimate object but it nevertheless has a quasi eloquence of the most touching kind. It allows the painter to use the brightest colours, which can be associated and combined with the greatest freedom and in an endless variety of ways, simply for the fun of using all types of colours, particularly the ones you simply can't use when faithfully reproducing a human head. And then again, might we not say that these masks, which look as if they have been turned to stone and are thus fixed for ever in a violent expression, in grimaces that will remain thus for all eternity, so clear and simple in their range of meaning, may have helped to people the empty universe in which Ensor used to shut himself up? *

Ensor had indeed increasingly been shutting himself up in the solitude of his studio. André de Ridder managed to discover the personal reasons underlying this behaviour: 'If it is true that something depressed him, temporarily preventing him from continuing his work, this was [not his failures but] more a number of family worries, about which he naturally remained discreetly silent. This affectionate creature suffered deeply from the bruises caused by clashes with his relations within a divided family.' But he did not divulge the reasons behind the changes of direction in his career and working methods. So we are reduced to forming our own theories and making deductions based on specific aspects of his work.

It would be reasonable to assume that after asking his family to sit for him during his Intimist period, he tried using other models that were better suited to his experiments in the use of colour. It therefore seems probable that his studio was full of masks or skeletons rigged out in old clothes or multi-coloured fabrics draped so as to give substance to the puppets that he was to bring to life and turn into the characters in his strange compositions, embellishing them with a few unusual trimmings as he painted them.

As we have just seen, it is difficult to distinguish between reality and imagination at this period. Yet in fact Ensor never painted from imagination. He always based even his most outlandish images on his experience of reality, even when they seem to be pure fantasy. Walter Vanbeselaere was right when he suggested that whereas in Naturalist

* *James Ensor* (Paris: Rieder 1930).

114

94 *Village Fair with Black Puddings* 1901

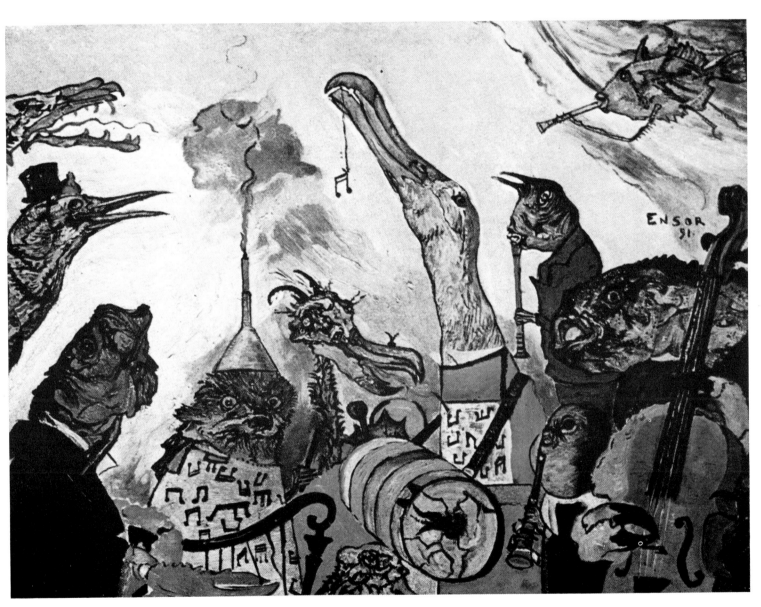

95 *Animal Musicians* 1891

overleaf 96 *Still-life with Peaches c.* 1895

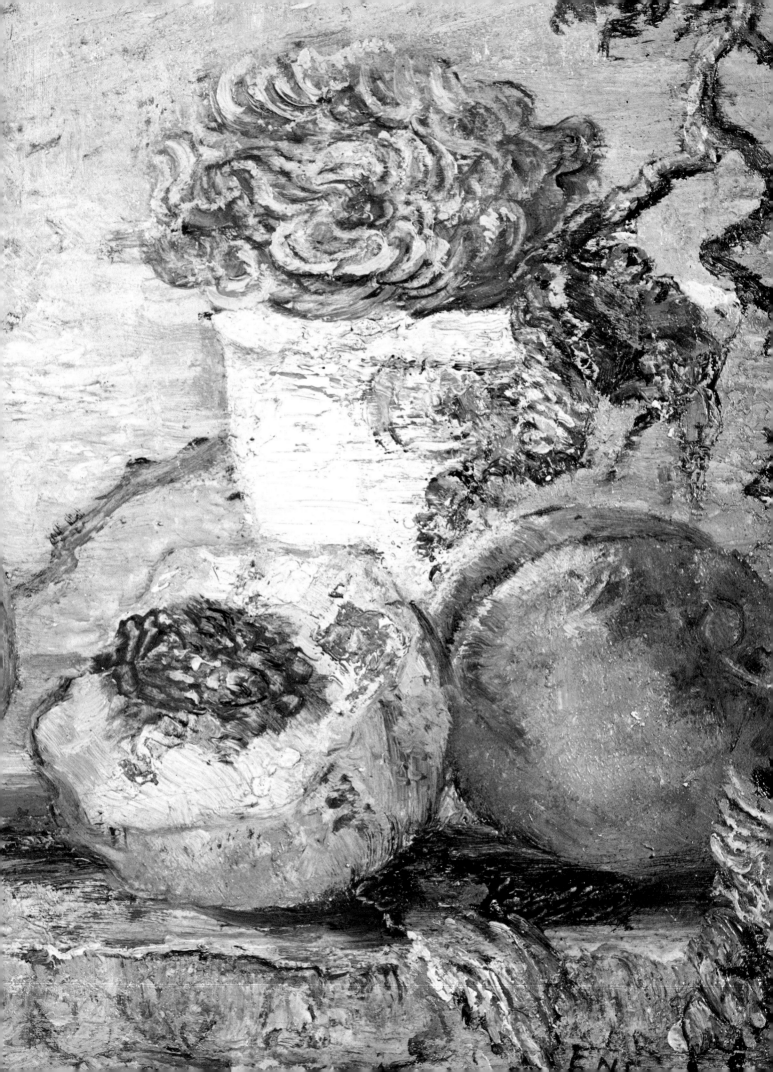

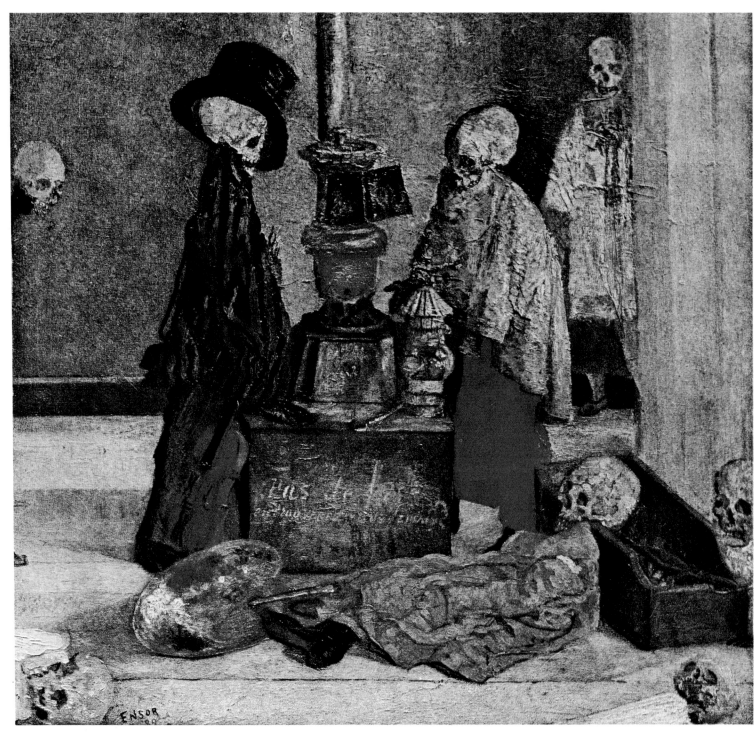

98 *Studio Props* (detail) 1889

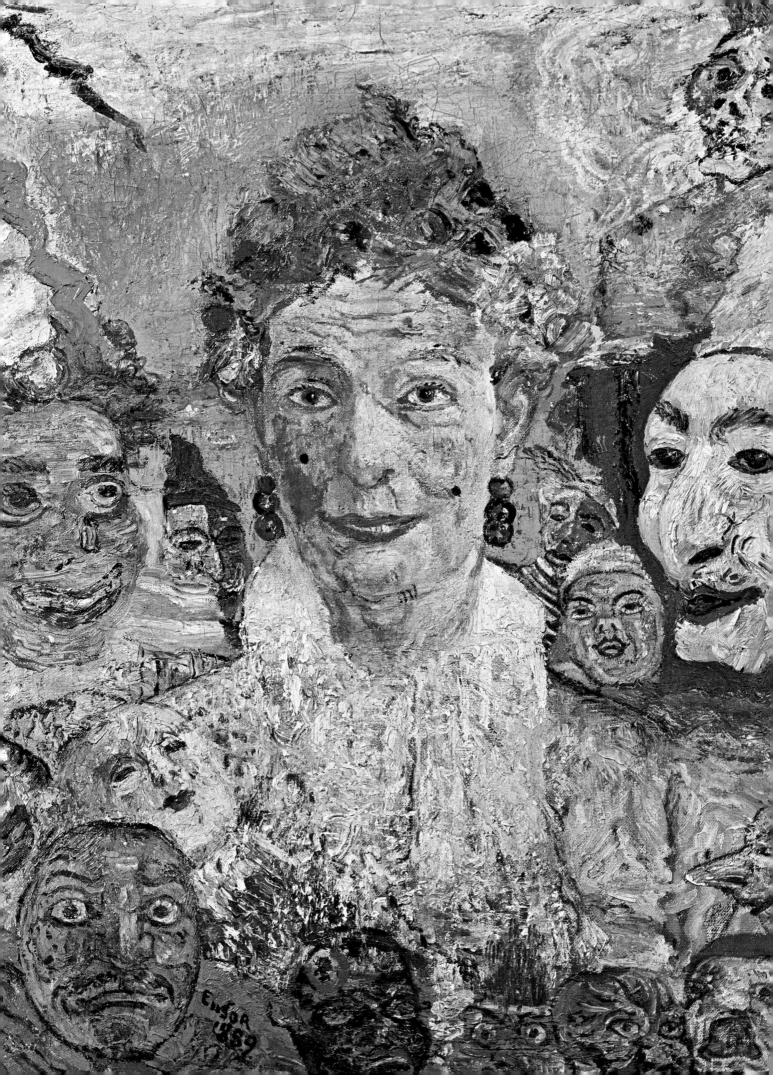

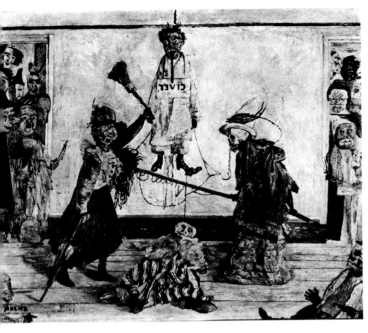

canvases such as *The Skate* (painted at the same period)

... the concrete data are imbued with the passion of a pair of eyes that are greedily struggling to gain a firm and all-embracing grip on reality... on the other hand, the world of the mask, in which he externalizes all the obsessions that haunt him and leave him with a disordered imagination, is continually swept by reminiscences of the concrete reality that he — a true northerner — cannot shake off. His masks act, move, stand upright — at all times and in all places they are living people.

In *Astonishment of the Wouse Mask* (1889, Antwerp Museum), an old lady out for a walk is draped in an indescribably sumptuous Indian shawl in autumnal colours. In *Skeletons trying to get Warm* (1889, Gendebien Collection) we are deeply moved by the sordid and pathetic spectacle of the stove.

In *Intrigue* (1890, Antwerp Museum) the procession of masks moves towards us with the persuasive power of a snapshot that has caught a moment of real life.

Whatever Ensor may have been experiencing at that date in the way of an obsession or fascination, he never resorted to the mask-substitute in a systematic fashion — indeed the variety in his work is clear evidence that he never took short-cuts by merely repeating earlier themes. He therefore continued to interpret other more commonplace Naturalist motifs during this period. In fact after *The Entry of Christ* he generally painted only one or two large canvases per year in his series of masked scenes. Thus in 1889 we have *The Astonishment of the Wouse Mask* and *Old Woman with Masks* (*La Vieille aux masques*), which is also known as *Bouquet d'Artifice*; in 1890 *Intrigue*; in 1891 *Masks Fighting over a Hanged Man* (*Masques se disputant un pendu*), plus two small panels called *Skeletons Fighting over a Red Herring* (*Squelettes se disputant un hareng saur*) and *The Terrible Musicians* (*Les Musiciens terribles*) or *Animal Musicians* (*Animaux musiciens*); and in 1892 *Strange Masks* (*Les Masques singuliers*). There is no doubt that these paintings are all highly important, showing Ensor at the height of is powers, but a still-life entitled *Studio Props* (*Attributs d'atelier*) or *Props from the Beaux-Arts* (*Attributs des Beaux-Arts*), painted in 1889, is equally important. And so are *The Skate*, an excellent piece of sensory painting, almost tactile in its effect, and *Kale* of 1892. Nor should we forget the two figures in *Melancholy Fishwives*, which dates from the same year; the observation in this painting is brilliantly Realist, in spite of the presence

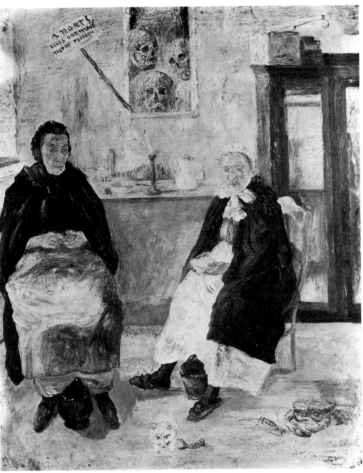

101 *Melancholy Fishwives* 1892

99 *Old Woman with Masks* 1889

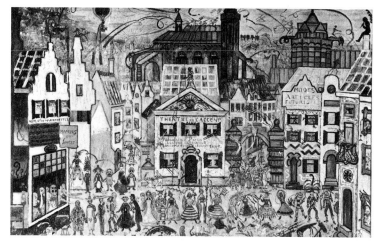

102 *Set for the ballet 'La Gamme d'Amour'* 1912

106 *Self-portrait with Masks* 1899

below left 103 *My Favourite Room* 1892

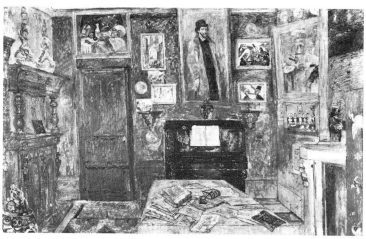

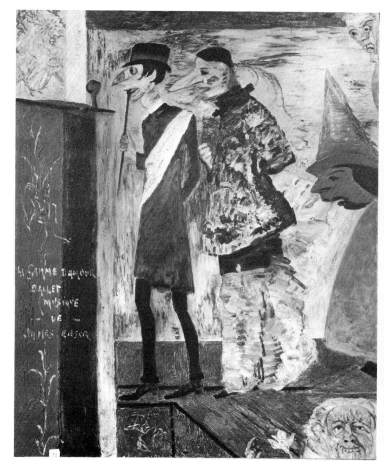

of three skulls and the inscription 'Death to them, they've eaten too much fish!'. Then again there's *My Favourite Room* (*Ma Chambre préférée*), in Tel Aviv Museum, and a landscape called *Boats Stranded on the Beach* (*Barques échouées*), which is based on an engraving executed in 1888.

Thus the exceptional richness of Ensor's very varied output at this period, when he was thirty, shows that his mature powers had blossomed in all directions.

104 *People Looking at a Poster for 'La Gamme d'Amour'*

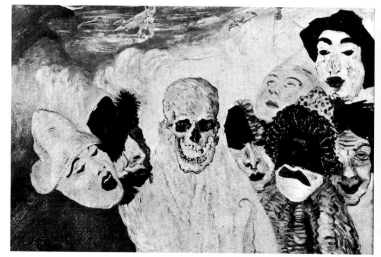

105 *Masks and Death* 1897

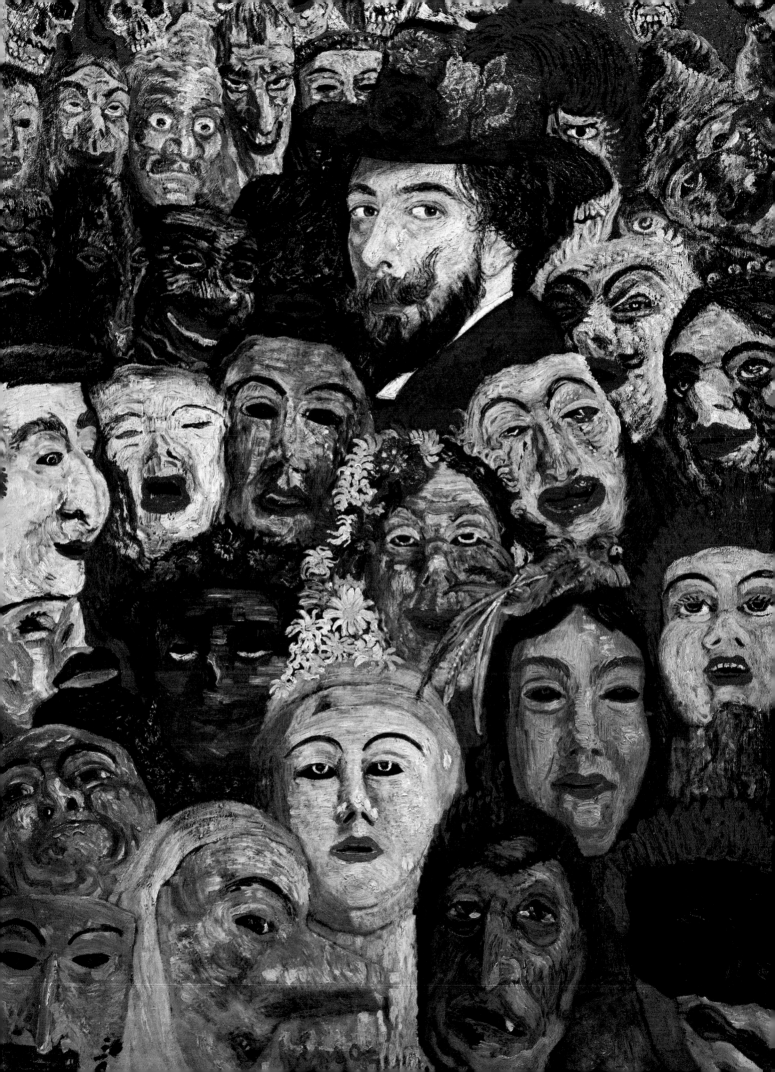

...ant d'une met aussi au
naturel; en pointe d'azur
à une coquille d'argent &c
en somme pour le titu

al en in alle akten dezen ti
tel aante nemen en het wa
pen dat Wij hem verleenen
te voëren zooals het

PRO LUCE NOBILIS SUM.

L. DIEKMANN

laire, et ceux de ses descen
dants qui seront appelés à
porter après lui le titre que
Nous lui concédons, d'une
couronne de baron et tenu
par

hier is beschreven en afge
beeld, te weten: Doorsneden:
in het schildhoofd van goud
met eene in natuurlijke ge
daante zon van keel uitko
mend

Premature Decline and
Belated Fame 1893 - 1949

This extraordinary flowering of masterpieces was followed by the disconcerting waning of Ensor's creative powers and of the marvellous gifts he had shown from a very early age. There is no doubt that he was still working within a few months of his death, but even his most fervent admirer would admit that with very few exceptions he did nothing after 1893 but repeat himself more or less laboriously.

His decline became obvious almost immediately. Thus whereas the canvas called *Skeleton Looking at Chinese Curios (Squelette regardant des chinoiseries)*, which was painted in 1895 and shows a return to the filtered and subtly coloured light of his Intimist interiors, is still worthy of his talent, *Masks and Death* (Liège Museum, 1899) repeats the theme of *Old Woman with Masks* but makes the juxtaposition of heads seem commonplace because of the heavy-handed treatment. Meanwhile *People Looking at a Poster for 'La Gamme d'Amour'* is an exact copy of a detail from the top right-hand corner of *The Entry of Christ* — mountebanks performing a knockabout turn on a fairground stage.

Later on, when he was no longer happy merely to make copies, Ensor's inspiration was limited to grotesque motifs, religious themes, mythological incidents and other equally mild themes painted on small canvases or simply drawn with coloured crayons, and his technique became increasingly uncertain.

How do we account for this premature decline in the creative faculties of one of the most original painters of the late nineteenth century? Perhaps we should see it as the price that must be paid for genius, just as death put an end to the career of his contemporary Vincent van Gogh, who rivalled him in his urge to revive the shapes and colours of Expressionism. At any rate we are reduced to making the vaguest conjectures. When Madame F.-C. Legrand was asked about this in an interview by L.L. Sosset for the Belgian journal *Clés* after her book *Ensor cet inconnu* (Brussels: Renaissance du Livre 1972) had appeared, she left the question open:

There was no longer the same inner tension. There were no more images conjured up by his conscience but instead images produced by an adulterated memory of what he had been. Verhaeren, who greatly admired him, recognized this as early as

107 Baron Ensor's coat of arms, designed by L. Diekmann

125

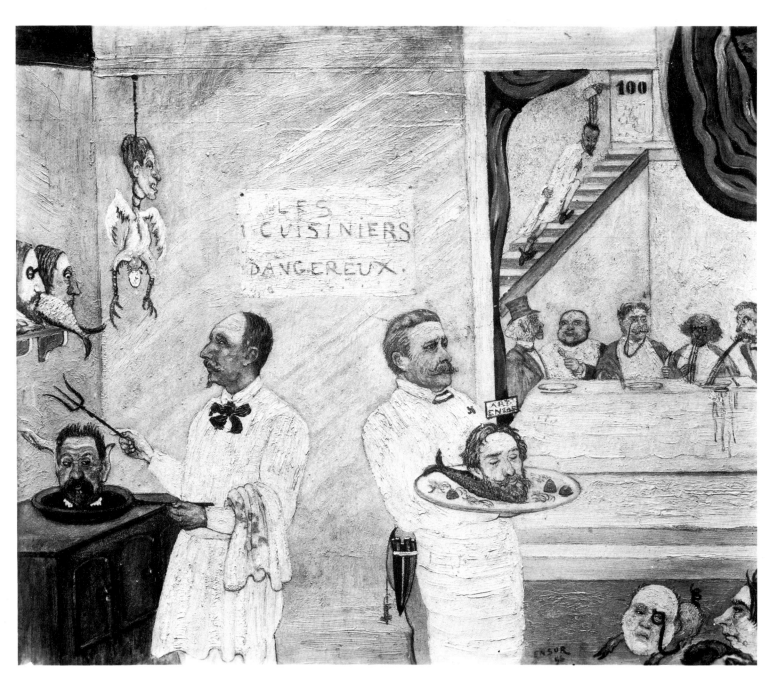

108 *The Dangerous Cooks* 1896

1908. Don't forget that there was a history of alcoholism
in his family that weighed heavily on his psyche. And he was
certainly an alcoholic himself. He may have suffered from
the after-effects of syphilis as well, though we can't be sure
about this. A doctor or psychiatrist could put us straight here.
At any rate Dr Herman Piron's investigations present us with
certain details that we can't simply brush aside.

Piron is a specialist who wrote a psychoanalytical study
in which he stated: 'It is impossible to understand Ensor's
development unless we take into account the tensions
undergone by his personality and the fact that ultimately the
figure of Christ had a decisive meaning for Ensor in that
he unconsciously identified himself with Him.' And his
conclusion is categorical: 'Like Christ, he died at the age
of thirty-three, but *his* resurrection involved his name rather
than himself.'

Indeed although Ensor's name has now been immortalized
and he ranks with the greatest figures in the history of
art he was not able to enjoy real fame until very late in his
life. In fact it was not until the end of the First World War
that the admiration of the younger generation for the way
his work gave free rein to the living forces of painting
replaced the ostracism he had suffered from artistic circles
in Belgium. The change in his reputation began with two
retrospective exhibition, one at the Giroux Gallery in
Brussels in 1920 and the other at the Salon de l'Art
Contemporain in Antwerp in 1921. These had the effect
of gradually convincing officials, dealers and collectors alike
of the value of Ensor's work, while the young group of
Flemish Expressionist painters and Brabantine Modernists
hailed him as a precursor of their own work.

But the old painter's fame was not permanently
established until 1929, when he was in his seventieth year.
In January and February of that year an extremely important
retrospective exhibition was held at the newly built Palais
des Beaux-Arts in Brussels, which was designed by Victor
Horta and had only just been opened. It brought together
virtually all the work he had ever done, consisting as it did
of 337 paintings, watercolours and pastels, 135 engravings
and 325 drawings. The King of the Belgians, Albert I, now
decided to ratify the public homage that was paid to Ensor
on this occasion by creating him a baron, while the town
of Ostend honoured her illustrious son by putting up a statue

109 Bust of Ensor by Rik Wouters

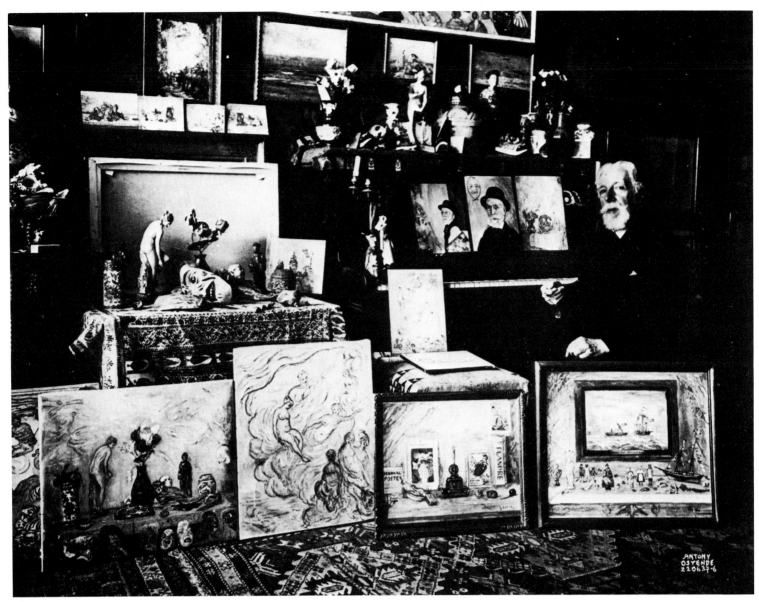

110 Ensor sitting at the piano surrounded by his own paintings

111 Ensor with his manservant

in the little garden behind the Kursaal. Legend has it that the local council gave him the choice of three sites and that before choosing he made a discreet survey to decide which spot had the most passers-by. Whether or not this is true, he definitely posed for Rik Wouters in 1913, but rejected the powerful bust sculpted by his young colleague in favour of a soapy monstrosity by an academic sculptor called de Valeriola.

In the interview already referred to F.-C. Legrand makes the following comment on the attitude of an innovator who reacted very badly when faced with new directions in art:

Does it not seem paradoxical to have to state that this man, who was one of the foremost innovators from 1885 to 1895, did not understand anything at all about the way painting subsequently developed? Cubism and Futurism disheartened him and he looked on them with contempt. He jeered at everything that happened after that. He was, and this must be stressed, a disconcerting creature, who even went so far as to turn his back on his earlier anarchic sympathies and try to obtain the title of baron by devious means! Does this represent an urge to become respectable or was he trying to play some practical joke? One does not necessarily exclude the other in a town whose population had behaved in a hostile fashion towards him for so many years.

Her interviewer, L.L. Sosset, stresses the point: 'In fact Ensor's notoriety is based solely on the creative warmth — or exuberance — he displayed during the privileged early years. For the rest, he suffered the damaging effect of a very long life and his behaviour in old age is sad to contemplate.'

While his fame was growing in Belgium, interest in his work also began to be shown abroad. He took part in a large number of exhibitions: the Venice Biennale (1924 and 1926), exhibitions of Belgian art in Basle (1925), Bern, Budapest and Stockholm (1927), Madrid (1928), Amsterdam, The Hague and Copenhagen (1931), Helsinki (1932), Rome and Berlin (1933), and so on. And of course his work was seen in Paris from 1921 onwards, with a one-man show at the Galerie Barbazanges in 1926, followed by the first official retrospective in 1932, at the Musée du Jeu de Paume. Jean Cassou was a particularly devoted admirer of Ensor and he showed his enthusiasm by presenting the first large posthumous retrospective at the Musée National d'Art Moderne, in 1954.

Nor must we forget that in 1933 Anatole de Monzie, the then French Minister of Education, who had opened the Ensor exhibition at the Jeu de Paume in 1932, had made the spontaneous gesture of going in person to Ostend to present the *cravate* of the Légion d'Honneur to the strange recluse who watched jealously over the treasures of his former genius in his house in the rue de Flandre.

129

Ensor and Symbolism

Does the warm welcome accorded to Ensor's work by the Symbolist writers on the Paris journal *La Plume* in 1898 entitle us to link the painter of masks with the Symbolist movement? Before we make up our minds on this point, we must remember that Symbolism had been essentially a wide-ranging current of poetic idealism that had appeared during the second half of the nineteenth century and had given rise to a new literary school in France. The term Symbolism was suggested by the poet Jean Moréas, in a manifesto printed in *Le Figaro* on 18 September 1886. He claimed that it was 'the only one that was capable of describing adequately the current tendency of the creative spirit in art', its main object being to 'clothe the Idea in a perceptible form'.

The Symbolist ideal soon attracted a large number of followers, who split into a series of separate groups, some more ephemeral than others. The movement spread very rapidly and had soon crossed the French border, appearing in Belgium almost simultaneously. The ground there proved exceptionally fertile and the movement was soon enriched by French-speaking Belgian writers such as Georges Rodenbach, Charles Van Lerberghe or Max Elskamp. But its foremost adherents were Maurice Maeterlinck and Emile Verhaeren, who probably introduced Ensor, a friend of his, to his colleagues on *La Plume*. He may have been helped in this by Octave Maus, who was the leading light behind the Les XX group and the Libre Esthétique. It is interesting to note that the exhibition organised by these two groups included virtually nothing of Ensor's but engravings. Many of these were distinguished from his Naturalist impressions of familiar landscapes by their more illustrative interpretation of imaginary themes that had caught the attention of the Symbolist writers and had convinced them that Ensor had a degree of spiritual affinity with them.

Apart from these circumstantial observations we must clarify Ensor's links with Symbolism in the field of the plastic arts and particularly within the Belgian School. Compared to its literary development and to the way it interpenetrated all the arts, the doctrine of Symbolism remained extremely vague and disparate in the field of painting. Thus it justified both Gustave Moreau's fabulous imagery and the academic allegories of Puvis de Chavannes, leading eventually

131

to Gauguin's Synthetism and to the pictorial innovations made by the Nabis in connection with the *Revue Blanche,* and last of all to the chromatic freedom of Fauvism and the paroxysm of Expressionism.

In the short term the Symbolists did not state the problem properly, as the Belgian art-historian Emile Langui firmly says in his book *Les Sources du XXᵉ Siècle*: 'By stressing the supreme importance of the intellect Symbolism paralysed the artist's ability to think in three dimensions and stifled the magic of colour. Because of the absolute aspect of Symbolist principles, it gave rise, particularly in painting, to a type of art that was lacking in authenticity and only too often lacking in genuine plastic feeling as well.' But Ensor cannot be reproached with this, for his talent as a painter was prodigious and it was not tied to any theories. Enclosed in the fierce solitude of his Ostend fastness, he was apparently unaffected by the influence of the Symbolist movement, though this was spreading in artistic circles in Brussels. Langui lists the most important Belgian artists involved in pictorial Symbolism:

The followers of Symbolism found a precursor and teacher in the Brussels-born Xavier Mellery (1855-1921). A friend of Charles de Coster and Camille Lemonnier, he enjoyed translating his idealism into noble allegorical figures, sepia on a gold background, in the manner of Walter Crane. Yet it is his drawings of domestic interiors, with velvety blacks in which he expresses the *silent inner soul of objects,* that show him to be a precursor of Seurat. His best pupil, Fernand Khnopff (1858-1921), is Symbolism incarnate, both physically and morally — compounded of pure aristocracy, lordly pessimism and classical culture. Steeped in Gustave Moreau and the English Pre-Raphaelites Burne-Jones and Rossetti, his work is redolent of solitude, silence, discretion and languor. *A Blue Wing* (painted in 1896-8) illustrates this *hothouse* art in which pale and beautiful ladies glide about, trailing their spleen among the arum lilies and their memories of the past. Henri Evenepoel (1872-99) was much more of a painter than Khnopff. Although he too was a product of Gustave Moreau's studio, he turned back to themes taken from every day life and was inspired by Manet's technique. Another Belgian painter, William Degouvre de Nuncques (1867-1935), has a very special place in the Belgian Symbolist movement, though he is more a Nabi than a Symbolist...

Symbolism underwent other developments in Belgium and its doctrine was asserted by the most academic supporters of the Pour l'Art and L'Art Idéaliste associations.

Paul Haesaerts discusses the confusions within the Symbolist movement in his *Histoire de la peinture moderne en Flandre*:

What is it then that goes to make up this peculiar intellectual atmosphere that spreads like a warm mist, fertile and stifling by turns, over certain areas of Europe at the turn of the century, and particularly over artistic life in Belgium in this period? Emotional attitudes, surely, rather than a rigid pictorial purpose. We find a higgledy-piggledy mixture of an urge to escape, a withdrawal into the self, a revolt against society, a wish to commune with nature, a vague hankering for a religious life of a theosophical tendency, a nostalgic harking back to the arts of the past, a fear of too firm a statement, a constant urge to take refuge in the bizarre and the esoteric.

But the fact that Ensor does display some of these states of mind, which are often common to avant-garde artists in any period, is not enough to prove that he belonged to some form of Symbolist movement, any more than the *La Plume* episode revealed this.

If we turn to Ensor's own opinion on this matter, it seems as though he never claimed any such affiliation, or even admitted that he was the remotest bit interested in the ideas held by the Symbolists or in those of his fellow-artists who belonged to the Symbolist School. In fact the opposite is true. We know that he always stopped taking part in artists' associations or Salons in which Symbolism was fashionable, along with other movements. His uncompromising individualism was ill-suited to any form of collective activity, and still less to any form of discipline in relation to theory or ideology. Also, he didn't think much of the people he considered to be 'false innovators who soon become pale and bloodless'. He exercised his biting and sarcastic wit particularly keenly at the expense of one of them, Fernand Khnopff, who had been a fellow-pupil at the Académie des Beaux-Arts in Brussels, scoffing at his 'soulless compositions, with their osteological harshness, which is always distinguished yet undistinguished, generally depicting gallinaceous guinea-fowl, stuffed to the gills with false distinction, peculiar birds without heads or tails, with huge jaws but not a sign of frontal bones or occiputs...'.

It's not surprising that most art-historians who specialize in Ensor's work have avoided the question of his links with Symbolism. This applies even to those who were

compelled to admit that Symbolism had dominated the intellectual and artistic climate in the last twenty years of the nineteenth century, which was a time when Ensor was moving on from the Intimist style of his Ostend interiors to his visionary paintings full of grotesque or macabre elements. But surely it would be fairer to see the fantasy world and the hallucinatory images he enjoyed creating as originating solely in his own genius, instead of looking for a symbolic meaning that would be justified by an outside influence that had nothing to do with his exceptional temperament, his unusual personality and his deep inner life.

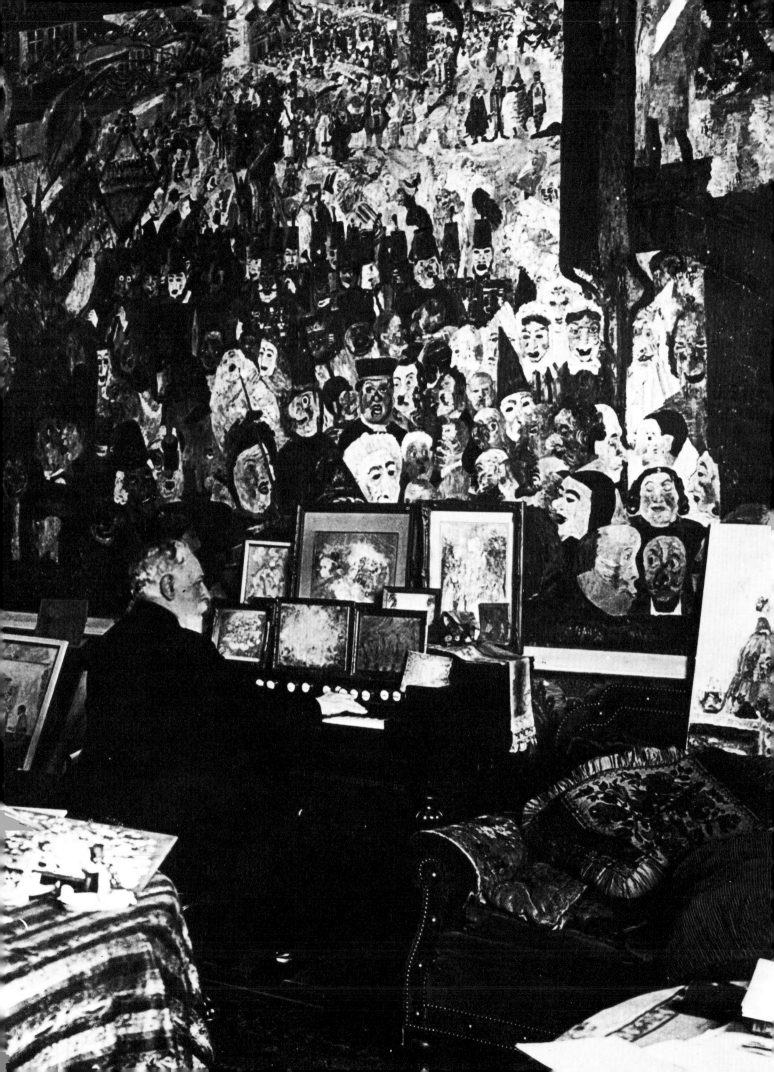

A Visit to Ensor

For many years Ensor's house represented a place of pilgrimage to the fountain-head of modern art. It was a museum to which the illustrious old painter had as it were appointed himself curator. There was a constant stream of visitors, both genuine admirers and the idly curious. When his state of health and mood permitted Ensor received them in a friendly fashion and perhaps even with secret delight. Of all the accounts that have been given of visits to Ensor the one recorded by Jean Stévo deserves to be repeated here because it conveys the ardour and emotion of a young man stirred by the vocation of painting.

Stévo, on holiday in Ostend, had visited a small exhibition of Ensor's etchings; it was here that he realised the full extent of the artist's greatness. (This must have been in 1930, because Stévo's text was printed in the *Revue Nationale* in May 1970 under the title 'Forty years ago with Ensor and Ramaekers'.) It was Ramaekers, a writer and journalist, who was to introduce the humble novice to the famous artist that very day. They met round a table in an old tavern called 'The Falstaff'. Ensor went there every evening during his daily constitutional and would linger over a pint of beer with little cubes of Cheddar cheese.

He appeared at ten o'clock on the dot, looking pale, remote, as if he were day-dreaming and his thoughts were miles away. When he noticed me he frowned. Who was this new face? Then he gave me a look full of irony, a smile of complicity... Ensor invited me to pay a visit to his house in the Rue de Flandre and I did so the following day...

I promptly came up against the 'ceremonial', because 'ceremonial' there certainly was in the Rue de Flandre.

You came to a souvenir shop with mother-of-pearl brooches in the shape of a prawn or a ship, inkwells set in shells, peculiar ashtrays decorated with turn-of-the-century figures, crucifixes set in shells, incredible boxes decorated with yet more coloured shells.

In a glass case in the window there was a mermaid with a herring's tail and a monkey's head, with shining eyes fixed on the horizon for all eternity. You pushed open the door, a bell jangled away and behind the counter appeared the melancholy Ernestine and the rigidly polite Auguste. 'Have you come to see the Master? Wait here, I'll go and find out.' The minutes ticked by. Eventually Auguste would come back, walk ahead of you, knock on the door. Wait. Then make up his mind to go in, announcing: 'Monsieur, there's a gentleman to see you.' Then you had your reward. You forgot the shop, the stairs, the corridor, as the palace, the enchanter's magic grotto were revealed.

112 Ensor playing the harmonium with *The Entry of Christ into Brussels* in the background

135

Light streaming in here and there, clusters of colours, masks,
lengths of silk, exquisite and delicate things, paper flowers,
fantastic dolls, a silver-spangled evening slipper, a woman's hat
covered with flowers. And in the midst of all these a skull,
a grinning death's head with a flower clenched in its jaws.
The whole place was in a charming muddle. You couldn't take
everything in at a single glance and the confusion was increased
by the ochre-coloured blinds, which were modestly lowered
to ward off the brutal shock of the immodest daylight, creating
little pockets of shadow. A sort of music, very gentle, delicate
and faded, seemed to waft out of all these objects. A quick glance
towards the canvases; masks, skulls, shells. The images
conjured up in the room reappeared in the paintings. Near the
door the old woman with masks flaunted her insolent conceit.

The Entry of Christ bowled you over: the hubbub of a gaudily
coloured crowd in a jovial mood. The bright blue paper on
the walls, which sometimes looked outrageously loud,
disappeared behind his paintings — the *Gamme d'Amour*
flaunted its colours, Ensor in a flowered hat looked down at you,
there was the portrait of Finch, the Virgin offering solace, and
then masks, always masks, and in the centre of this motley
throng, of all these presences, a calm, smiling, relaxed and
handsome old man with curly white hair and a pink complexion
... Ensor.

The first time I saw him I was a little bit afraid of him:
I felt I was in the presence of a magus. He had the same superb
tranquillity and the same sovereign authority.

Ensor showed me his paintings. Then he asked questions
about me, asked me if I painted as well and suggested I should
show him my paintings. He sat down at the harmonium and
improvised a gentle, old-fashioned melody, rather like a fairground
tune, but so fragile and dreamy that it seemed to be a reflection
of some other tune you'd heard before, in your childhood.
That was how we became friends.

113 Ensor playing the harmonium

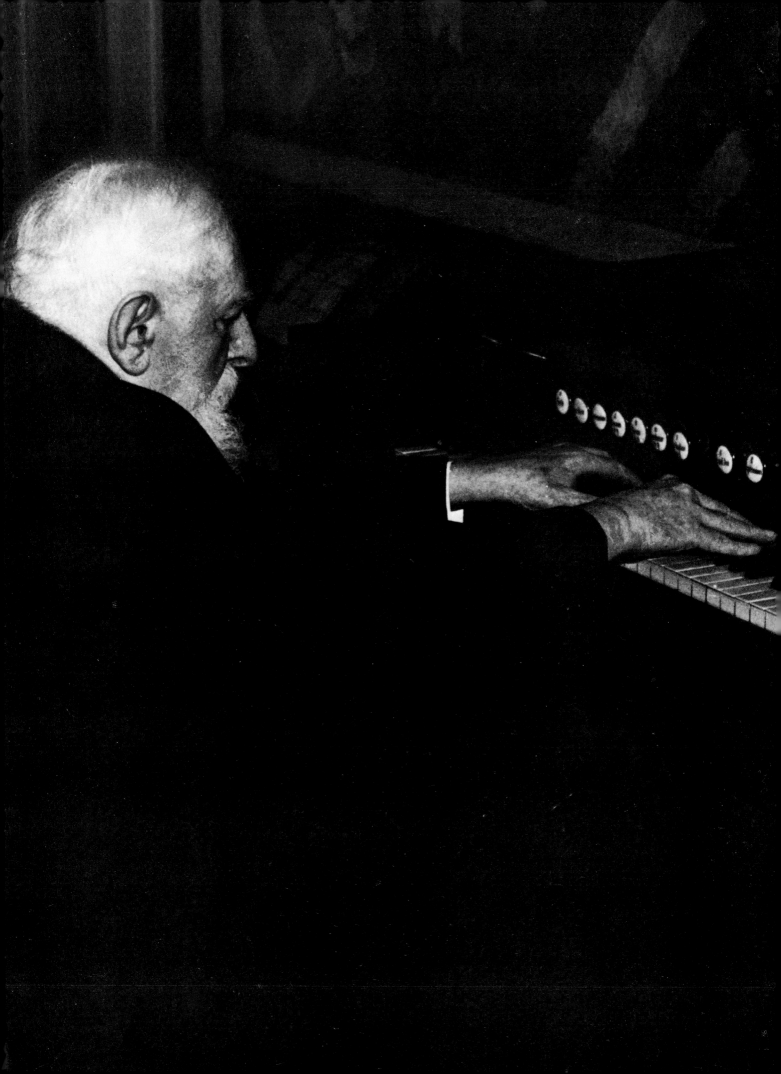

Postscript: Ensor Today

As we have seen, Ensor's belated recognition was not formally ratified until after the First World War, when he was approaching sixty, and twenty-five years after he had done all his major work. It wasn't until 1920 that official prejudice against him subsided and the Belgian Ministry of Fine Arts made their first sizeable purchase of his works. A letter from Ensor to the minister of the day shows that they bought three paintings and three drawings. Until then the State had shown no interest in this major artist, except on one occasion, when *The Lamp Boy* was acquired for the Brussels Museum in 1896.

When he died on 19 November 1949, shortly before his ninetieth year, James Ensor had been firmly situated in his posthumous glory for many years (indeed we might even say he'd been immobilized in it!). The fact that the major part of his *œuvre* dated back to the previous century only increased this impression. Once official recognition had made him the most important figure in the history of modern painting in Belgium — or in Flanders if you prefer — all his masterpieces and most of his major works gradually appeared in Belgium's public collections. In some cases they were bought by the institution concerned; in others they were given by the patrons who had grasped the importance of his work before anyone else.

Most of his work can be seen in two museums — the Musée des Beaux-Arts in Antwerp and the Musée d'Art Moderne in Brussels — but there are also one or two in the most important provincial museums, such as those in Ostend, Liège and Tourna. The Print Room in the Bibliothèque Royale in Brussels has all his engravings. On the other hand very little of his work is on show in foreign museums. The few exceptions include *Lady in Distress* (1882), which was acquired for the Musée du Jeu de Paume and now belongs to the Musée d'Art Moderne in Paris. The Kunsthalle in Mannheim in Germany acquired *Still-life with Cockerel* (1894) in 1956, while only one canvas is on show in the United States — *The Temptation of St Anthony* in the Museum of Modern Art in New York. The Tate Gallery in London has *Effect of Light* (1935).

It is fortunate that Ensor's relatively small output has remained reasonably intact. And, after all, his rightful place is surely in the context of the modern Belgian school, since he remains its most illustrious representative, as well as having been if not its initiator at least a genuine leavening influence. Although he has been seen as a precursor of Expressionism, or even as inspiring it, on the same footing as Van Gogh and Edvard Munch, he never had any disciples. He could not have led a school because he was never for one moment doctrinaire and never instigated a single aesthetic movement. He was exceptional in that he was completely autonomous, owing nothing to anyone and offering no example but that of fundamental originality and ferocious individuality. His fascinating work remains to remind us that during his creative years James Ensor was a spontaneous and indomitable genius.

Chronology

	Ensor's life	Events in the arts	Historical and social events
1824		Romanticism carries the day at the Paris Salon.	
1830			Revolution breaks out in Brussels, resulting in Belgium gaining her independence; the Belgian provinces are separated from the Netherlands, to which they have belonged since the Congress of Vienna in 1815.
1831			Leopold I, first King of the Belgians, comes to the throne.
1850		Realism holds sway under the influence of Courbet; Belgian painters affected are Charles de Greux (who painted his first Realist canvas in 1853) and Liévin de Winne, a portrait-painter. The novelist Hendrik Conscience, head of the Flemish movement and a follower of Romanticism, is converted to Realism. Van Gogh is born.	
1851		Constantin Meunier (1831-1905) shows his first canvas at the Brussels Salon.	
1852		The classical painter Jean Portaels (a pupil of François-J. Navez, who was a disciple of David) receives official approval, and subsequently becomes head of the Académie Royale des Beaux-Arts in Brussels, a post he held when Ensor was a student there from 1877 to 1880.	

	Ensor's life	Events in the arts	Historical and social events
1854		Henri de Braekeleer becomes a student at the Antwerp Académie des Beaux-Arts, where he becomes friends with a fellow-student, Jan Stobbaerts; the two of them were later to win the battle for Realism against Romanticism and Neo-Classicism. Birth of the Naturalist writer Georges Eckhoud.	
1855		The Realist painter Charles Verlat replaces Gustave Wappers, the leader of the Romantic School in Belgium, as head of the Antwerp Académie. Birth of Emile Verhaeren, who was later to become one of the first people to recognize the exceptional qualities of Ensor's work and to write a monograph on him (1908).	
1856		Birth of Jakob Smits and of Léon Frédéric.	
1857		The animal-painter Joseph Stevens (who specialized in dogs) and his brother Alfred, who painted portraits of elegant women, start working in Paris and are much admired.	
1858		The first exhibition of the work of Henri de Braekeleer is held at the Antwerp Salon. The Flemish poet Guido Gezelle writes his first poems.	
1859		Navez leaves his post as head of the Brussels Académie Royale des	

	Ensor's life	Events in the arts	Historical and social events
		Beaux-Arts, which he has held since 1830. Birth of Seurat.	
1860	James Ensor is born in Ostend on 13 April	Realism develops in Belgium with Hippolyte Boulanger's paintings of forest interiors, and landscapes by X. de Cock, A.J. Heymans, Fourmois, and De Schampheleer, all of whom have links with the Barbizon School. In England Whistler attacks the Pre-Raphaelites.	Social unrest in Brussels.
1861		Octave Pirmez heralds a renaissance of Belgian literature written in French, while Hendrik Conscience and Guido Gezelle head the group of Flemish writers.	
1863		Hippolyte Boulanger settles in Tervueren so that he can embark on Plein-Air painting. He is soon joined by a whole colony of painters specializing in carefully detailed landscapes. After a period in Paris, where he sees a good dead of Corot and Courbet, the painter Louis Artan returns to Brussels and subsequently settles on the Belgian coast to fulfil his vocation as a painter of seascapes, which he discovered when he was in Brittany. Death of Delacroix. Manet's *Le Déjeuner sur l'herbe* creates a scandal at the Salon des Refusés in Paris.	
1864		Baudelaire stays in Brussels.	

	Ensor's life	Events in the arts	Historical and social events
1865			Death of Leopold I; he is succeeded by his son Leopold II.
1866		The Tervueren group hold their first joint exhibition.	
1867		Ingres dies at the age of eighty-two. One of Cézanne's paintings is turned down by the Paris Salon. The Universal Exhibition in Paris represents the apotheosis of the Second Empire before its collapse in 1870.	Karl Marx's *Das Kapital* is published.
1868		The Société Libre des Beaux-Arts is founded in Brussels and brings together non-conformist artists.	Marx's theories are defended at the annual congress of the International Workmen's Association in Brussels.
1869		Death of Navez, whose David-esque style predominated in 1830.	
1870		Death of Charles de Greux, who had pointed to the move to Realism in Belgium and had expressed his social preoccupations in his work. Boudin visits Brussels and Antwerp. Sisley, Monet and Pissarro discover Turner's work in London.	The Franco-Prussian War breaks out.
1871		The Société Libre des Beaux-Arts founds a journal called *L'Art Libre* to fight against academicism and history painting. Artan works in Blankenberghe, on the North Sea coast. In England, Whistler paints a series of 'Nocturnes'.	The Commune and the siege of Paris.

	Ensor's life	Events in the arts	Historical and social events
1872			Cézanne settles in Anvers-sur-Oise, where he will remain until 1874; he sees a good deal of Pissarro at Pontoise and abandons romantic themes, instead lightening his palette so that he can made direct studies of landscape.
1873	Ensor, now aged thirteen, has his first drawing lessons and attempts to paint for the first time.	The novelist Camille Lemonnier turns to Naturalism. Verlaine is put in prison in Mons after his quarrel with Rimbaud, whose *Une Saison en Enfer* is published this year. Manet, Sisley, Renoir and Monet paint their first 'Impressions' at Argenteuil.	
1874		Death of Gustave Wappers and of Hippolyte Boulanger (at thirty-seven). Félicien Rops goes to live in Paris. First of eight public exhibitions in Paris of the work of the Impressionists (the last is held in 1886).	
1875		Henri de Braekeleer paints *Man with Chair*. A new art association called 'La Chrysalide' is formed; its members — Artan, Dubois, Rops, Vogels and Pantazis — are all Realist painters. Death of Corot, Millet, Carpaux and Barye.	
1876	Paints his first landscapes from nature, working in the dunes round Ostend and on the Flemish plain.	Vogels, a self-taught Impressionist painter with a fiery temperament whose work is based on instinct, starts painting at the age of forty.	

	Ensor's life	Events in the arts	Historical and social events
		Isidore Verheiden paints forest landscapes at Hoeylaert that link him with the Barbizon School. Verhaeren, Giraud, Max Waller and other writers embark on their literary careers and subsequently found the 'Jeune Belgique' movement.	
1877	Enters the Académie Royale des Beaux-Arts in Brussels at the age of seventeen.		
1878		Van Gogh starts drawing in the coalmining district of Belgium. Portaels is appointed head of the Académie des Beaux-Arts in Brussels, where he has been teaching for ten years. Cézanne settles for good in his native town, Aix-en-Provence.	Official opening of the Ostend Kursaal (22 June), designed by the French architect Chambon. (It was destroyed in the Second World War and has been replaced by a modern building.)
1879	Paints *Woman with a Turned-up Nose* and *Self-portrait at the Easel*. Beginning of his 'dark period', which lasts five years and is made up of domestic interior scenes and portraits.		
1880	Leaves the Académie in Brussels and returns to Ostend. *The Blue Flask, The Lamp Boy, The Colourist, Still-life with Duck, Apples, Middle-class Drawing-room, Lady in Blue*.	Artan moves to La Panne and paints seascapes.	

	Ensor's life	*Events in the arts*	*Historical and social events*
1881	Takes part of the first time in a 'Chrysalide' exhibition. Paints his most important 'dark period' paintings (*Russian Music, Afternoon in Ostend, Dark Lady, Portrait of my Father*).	Waller founds the journal *La Jeune Belgique* and Octave Maus runs the new *L'Art Moderne*; both journals support avant-garde ideas.	
1882	Paints *Woman Eating Oysters* (which is rejected by the Antwerp Salon and by the 'Essor' group in Brussels), *Lady in Distress* and *The Tramp*.	Birth of Rik Wouters. Van Gogh decides to make painting his career and studies in Mauve's studio in The Hague.	
1883	First mask painting (*Scandalized masks*); *Portrait of Ensor in a Flowered Hat* and *The Oarsman* (which anticipates the strength of Permeke).	Verhaeren's *Les Flamandes* is published. Death of Hendrik Conscience, the father of popular Flemish literature. 'Les XX' group is founded by breakaway members from 'L'Essor'. Camille Lemonnier is crowned 'Marshal of Belgian letters' by the 'Jeune Belgique' group. Death of Manet. Gauguin leaves the bank to concentrate on painting.	
1884	All the paintings he sends to the Brussels Salon (including *Afternoon in Ostend*) are rejected.	First 'Les XX' exhibition (with Whistler and Rodin). Salon des Indépendants founded in Paris. Pre-Raphaelism in fashion in London.	
1885	Adopts a lighter and more fluid technique, with brighter colours. Tackles	Seurat paints *La Grande Jatte*. Toulouse-Lautrec arrives in Montmartre.	The *Parti Ouvrier Belge* and the journal *Le Peuple* are founded.

	Ensor's life	Events in the arts	Historical and social events
	imaginary and macabre themes (*Skeleton looking at Chinese Curios*).	Van Gogh paints *The Potato-Eaters* at Nuenon. Liège introduces the new generation of Russian composers to Belgium. (Ensor had painted *Russian Music* in 1881.)	
1886	First engravings (*The Cathedral*). Paints *Children Dressing*.	Van Gogh studies under Verlat at the Antwerp Academy and is considered to be a 'mediocre' painter. Renoir, Monet and Redon are invited to join the Les XX group in Brussels. Permeke born in Antwerp. Georges Minne carves his first sculptures. Albert Meckel founds *La Wallonie*, a Franco-Belgian Symbolist journal, in Liège. Gauguin at Pont-Aven. Edvard Munch starts painting in Norway.	
1887	*Beach Carnival*.	Les XX exhibit Seurat's *Grande Jatte*, which converts Van Rysselberghe and other Belgian paintes to Pointillism. Van Gogh, now working in Paris, adopts a lighter style of paintings.	
1888	*The Entry of Christ into Brussels*.	Emile Claus is influenced by Monet in Paris. Van Gogh moves to Arles. Bonnard, Vuillard, Maurice Denis and Ranson meet at the Académie Julian in Paris and soon form the Nabis group.	
1889	Les XX reject all the paintings he has submitted	Maeterlinck's *Serres Chaudes* and Van Lerberghe's *Flaireurs*, both	

	Ensor's life	Events in the arts	Historical and social events
	(including *The Entry of Christ*). Paints *The Astonishment of the Wouse Mask, Studio Props, The Rebel Angels struck down, Old Woman with Masks, Still-life with Fruit*. Eugène Demolder's *James Ensor* published in Paris (Brussels 1892).	Symbolist works, are published.	
1890	*Intrigue, The Assassination, Still-life with Peaches*.	Vogel's style becomes livelier and light takes precedence over form in his misty landscapes. Artan dies at the age of fifty-four. Les XX show some of Van Gogh's Arles paintings (*Sunflowers, Orchards in Flower, The Red Vine*) and Cézanne's first *Card-players*. Van Gogh commits suicide in Auvers-sur-Oise, at the age of thirty-seven. Munch visits Paris and Germany.	
1891	*Christ calming the Storm, Masks fighting over a Hanged Man, Skeletons fighting over a Red Herring, Music in the Rue de Flandre, Garden of Love, Strange Masks*.	Henri de Greux shows his *Ravaged Christ*. Vuillard's first exhibition at the *Revue Blanche*. Bonnard shows his first paintings at the Indépendants.	
1892	*Melancholy Fishwives, Skate, Kale, Boats Stranded on the Beach, My Favourite Room*.	The young Henri Evenepoel leaves for Paris. The 'Ideist' painter Jean Delville founds the 'Pour l'Art' association in Brussels. An exhibition of Munch's work in Berlin creates a scandal and influences the younger generation of German painters.	

	Ensor's life	Events in the arts	Historical and social events
		Matisse attends the Académie Julian, while Rouault is a pupil in Gustave Moreau's studio at the Ecole des Beaux-Arts in Paris.	
1893	Ensor's best work is now done and a decline sets in. His output begins to slow down, and he produces no more major works.	The Les XX group splits up and is replaced by 'La Libre Esthétique', led by Octave Maus.	
1894		Van Rysselberghe becomes the leader of the Divisionist movement in Belgium. Munch starts on his graphic work.	
1896	Exhibition of Ensor's work in Brussels, organized by the novelist Eugène Demolder, who wrote the first monograph on Ensor.	First Salon de L'Art Idéaliste (Delville, Montald, etc.) in Brussels. Death of Guillaume Vogels at the age of 60. The French journal La Plume devotes a special issue to the Belgian painter and engraver Félicien Rops.	
1898	A special issue of La Plume is devoted to Ensor.	Death of Rops.	
1899		The Laethem-Saint-Martin School (which gave rise to Flemish Expressionism fifteen years later) is founded.	
1904		A large-scale retrospective of Impressionism is organized by the Libre Esthétique; it supports the 'Luminist' style in Flemish painting, the main representative of which is Emile Claus.	

	Ensor's life	Events in the arts	Historical and social events
1905		The Fauves group show at the Salon d'Automne in Paris. The 'Die Brücke' group is formed in Dresden by Kirchner, Heckel and Schmidt-Rottluff; this is the first indication of the new German Expressionist style, of which Ensor was subsequently recognized as a precursor, along with Munch, Gauguin and Van Gogh.	
1906-7		Picasso paints *Les Demoiselles d'Avignon*.	
1908	Verhaeren's *Ensor* is published.	Rik Wouters, originally a sculptor, starts painting and engraving at the age of twenty-six. The paintings that Georges Braque submits to the Salon d'Automne initiate the Cubist style.	
1909			Death of Leopold II of the Belgians. He is succeeded by Albert I.
1910		Kandinsky paints the first abstract watercolour.	
1911		Kandinsky founds the 'Blaue Reiter' group in Munich with Marc and Macke; this represents the second phase of German Expressionism.	
1914		The eighth Contemporary Art exhibition in Antwerp honours Van Gogh, Ensor, Jakob Smits and Rik Wouters.	Outbreak of the First World War. Ostend is subsequently occupied by the Germans.
1920	Large retrospective at the Galerie Giroux in Brussels.		

	Ensor's life	*Events in the arts*	*Historical and social events*
1924		The first Surrealist manifesto is published.	
1929	Retrospective exhibition of all Ensor's work at the Palais des Beaux-Arts in Brussels, which has just opened (January and February). King Albert I makes Ensor a baron.		
1932	Ensor exhibition at the Musée du Jeu de Paume in Paris.		
1933	Anatole de Monzie, French Minister of Education, makes a special journey to Ostend to present Ensor with the *cravate* of the Légion d'Honneur.		
1940			The Germans enter Ostend.
1949	Death of Ensor at the age of eighty-nine.		

Bibliography

General

Haesaerts, Paul *Histoire de la Peinture Moderne en Flandre*
Brussels, 1959
Legrand, F.C. *La Peinture en Belgique, des primitifs à nos jours*
Brussels, 1954

Monographs

Avermaete, Roger *James Ensor* (Monographies de l'Art Belge,
1st series, no. 4) Antwerp, 1947
Croquez, Albert *L'œuvre gravé de James Ensor* Geneva, 1947
Delteil, Loys *Catalogue de l'œuvre gravé de James Ensor*
Paris, 1925
Demolder, Eugène *James Ensor* Paris, 1889, Brussels, 1892
Desmeth, Paul *James Ensor* Brussels, 1926
Les Ecrits de James Ensor Brussels, 1921
James Ensor, peintre et graveur special issue of *La Plume*
Paris, 1898
Fels, Florent *James Ensor* Geneva and Brussels, 1947
Propos d'artistes Paris, 1925
Fierens, Paul *Les dessins de James Ensor* Brussels, 1944
Fierens, Paul *James Ensor* Paris, 1943
Haesaerts, Paul *James Ensor* New York and London, 1959
Hellens, Franz *James Ensor*, in *Niewe Kunst* Amsterdam, 1924
Lebeer, Louis *James Ensor aquafortiste* (Monographies de l'Art
Belge, 5th series, no. 5) Antwerp
Legrand, F.C. *Ensor cet inconnu* Brussels, 1972
Marlier, Georges 'James Ensor et le double aspect de son art',
L'Amour de l'Art Paris, November 1928
De Ridder, André *James Ensor* (Les Maîtres de l'Art Moderne
collection, no. 31) Paris, 1930
Le Roy, Grégoire *James Ensor* Brussels, 1922
Verhaeren, Emile *James Ensor* Brussels, 1908

Notes on the plates

1 Ensor seen in profile. (Photo: Antony, Ostend)

2 Ensor painting in his studio-cum-living-room.
(Photo: Antony, Ostend)

3 The shell-shop at 27 rue de Flandre, Ostend, now the Ensor Museum. (Photo: Luc, Ostend)

4 *The Flemish Plain* 1876. Collection M. Mabille, Brussels.
'At the age of fifteen I was painting views of he countryside round Ostend from Nature; these were minor and unpretentious works, painted in oil on pink cardboard.'

5 *Shells* 1896. Collection Bénédict Goldschmidt, Brussels.

6 *Shells* 1895. Formerly in the collection of Baron de Broqueville, Brussels.

7 Ensor on the balcony of the old Kursaal. (Photo: Antony, Ostend)

8 A walk on the breakwater. From left to right: James Ensor, the Brussels painter Creten and Ensor's niece, Madame Daveluy, in 1928. (Photo: Madame Creten)

9 Ensor in Ostend 1926.

10 The beach and Kursaal in Ostend. The Kursaal was built in 1878 to the designs of Chambon.

11 Ensor on othe breakwater overlooking the sea, 1926.
(Photo: Madame Creten)

12 Dedication by Ensor in coloured crayons on a copy of Paul Fierens' book *James Ensor* (Paris: Hypérion). It reads: 'Here, a signature pledges the friendship I bear, pictorially speaking, to Jean Milo, the most devoted of friends, both in heart and in mind. James Ensor, Ostend, first of March 1945.'

13 *Portrait of Eugène Demolder* 1893. Collection Marcel Mabille, Brussels.

14 The beach in front of the old Kursaal, Ostend *c.* 1910.

15 *Self-portrait of the Artist at his Easel* 1879. Private collection, Ghent.

16 *Woman with a Turned-up Nose* 1879. Musée Royal des Beaux-Arts, Antwerp. Ensor's first canvases, painted when he was a student at the Académie Royale des Beaux-Arts in Brussels, are masterly in their execution and represent some

of his finest paintings. The treatment largely involves thick paint applied with accurate brushstrokes or slapped on with a knife.

17 *Self-portrait* 1879.

18 *The Blue Flask* 1880. Private collection, Brussels.

19 *The Colourist* 1880. Collection Madame Wodon, Brussels.

20 *Still-life with Duck* 1880. Musée de Tournai.

21 *The Lamp Boy* 1880. Musée d'Art Moderne, Brussels.
'*The Lamp Boy* represents a sort of forfeit of the inner modelling of the face, with black contoured against black. The lamp too represents a forfeit, its copper alive with reflections and creating an incandescent centre among all these shadows.' (F.C. Legrand, *La Peinture en Belgique des Primitifs à nos jours,* 1954)

22 *The Dark Lady* 1881.

23 *Lady in Blue* 1880.

24 *Lady in Distress* 1882. Musée National d'Art Moderne, Paris.

25 *Tramp Trying to Get Warm* 1882. Ostend Museum.
This canvas was destroyed when Ostend was bombed during the Second World War.

26 *Russian Music* 1881. Musée d'Art Moderne, Brussels.

27 *Afternoon in Ostend* 1881. Musée Royal des Beaux-Arts, Antwerp.

28 *Middle-class Drawing-room* 1880. Private collection, Brussels.
This sketch is the first version of painting on the same subject executed in 1881, in Ensor's series of domestic interiors. The chromatic brilliance and restrained light-effects in paintings of this kind belie the 'dark period' label that is generally accepted for Ensor's first period, before he lightened his palette and used splashes of pure colour.

29 *The Oarsman* 1883. Musée Royal des Beaux-Arts, Antwerp.
The powerful realism of this painting anticipates the Expressionism of the massive figures of sailors that Permeke was to paint forty years later.

30 *Kale* 1892. Formerly in the collection of Philippe Dotremont, Brussels.

31 *The Skate* 1892. Musee d'Art Moderne, Brussels. This

splendid piece of sensory, almost tactile painting, shows how easily Ensor could make the transition from the real world to the world of the imagination, and vice versa, during his greatest period.

32 *Woman Eating Oysters* 1882. Musée Royal des Beaux-Arts, Antwerp. This painting forms a link between the chiaroscuro of Ensor's first paintings and his triumph over colour and light. 'What we heve is the Intimist feeling of a painter such as De Braekeleer, with his love of reflections, but also something broader and heftier; there is a magnificent feeling of solidity about these shapes that are proud to assert their authority, a feeling of abundance, of fullness with no ulterior motive, that is reminiscent of Jordaenes.' (F.C. Legrand, *La Peinture en Belgique*)

33 *Woman Eating Oysters* 1882 (detail).

34 *Scandalized Masks* 1883. Musée d'Art Moderne, Brussels. This is still a realistic scene, treated in chiaroscuro, with the masks merely accessories. The people have put them on to accentuate the strange drama of the situation.

35 *Music in the Rue de Flandre* 1891. Musée Royal des Beaux-Arts, Antwerp. This small panel depicts the carnival musicians from *The Entry of Christ* winding in a procession between houses drawn in great detail in rectilinear style. Ensor has used the same downwards-plunging angle of vision as in his first views of Ostend.

36 *Rue de Flandre in the Snow* 1882. Formerly in the collection of Francois Franck, Antwerp.

37 *The White Cloud* 1882. Musée Royal des Beaux-Arts, Antwerp.

38 *Portrait of Ensor in a Flowered Hat* 1883. Ensor Museum, Ostend.

39 *The Good Judges* 1894, etching. Private collection, Brussels.

40 *Rue de Flandre in Ostend* 1881. Private collection, Antwerp.

41 *Rooftops in Ostend* 1898 (detail). Private collection, Brussels.

42 *Beach Carnival* 1887. Musée d'Art Moderne, Brussels. This small canvas seems to acknowledge the influence of Turner, whose work Ensor discovered when he went to London at about this date. 'In Turner's work, chiefly his *fêtes galantes* set on the Venice canals, with their brilliant light effects, Ensor not only found an imaginary universe related to the one whose confines he himself been exploring for so many years, he also found a range of luminous colours seventy-five years older than those used by the Impressionists.

He was going to be able to use these to depict the visions of his own imaginary world.' (Walter Vanbeselaere, chief curator of the Musée Royal des Beaux-Arts, Antwerp)

43 *The Astonishment of the Wouse Mask* 1889. Musée Royal des Beaux-Arts, Antwerp. '... the world of the mask, in which he externalizes all the obsessions that haunt him and leave him with a disordered imagination, is continually swept by reminiscences of the concrete reality that he — a true northerner — cannot shake off. His masks act, move, stand upright — at all times and in all places they are living people. In *Astonishment of the Wouse Mask* an old lady out for a walk is draped in an indescribably sumptuous Indian shawl in autumn colours.' (Vanbeselaere)

44 *The Rebel Angels Struck Down* 1889. Musée Royal des Beaux-Arts, Antwerp. The very free treatment in this piece of painting is derived from the graphic technique he used in his etchings; it seems to anticipate the gestural style of the lyrical Abstraction and Action Painting of the fifties.

45 *Studio Props* 1889.

46 *Consoling Virgin* 1892. Collection A. Tavernier, Ghent. 'A fascinating page, almost Pre-Raphaelite in feeling.' (Vanbeselaere)

47 *Still-Life with Fruit* 1889. Private collection, Paris.

48 Cover of the special issue of *La Plume* devoted to the paintings and engravings of James Ensor (1 November 1898).

49 Portrait of Emile Verhaeren 1890.

50 *The Lively and Radiant Entry into Jerusalem* 1885. Charcoal on paper. Collection Dr Delacroix, Hoeylaert.

51 Cover of the 21 December 1911 issue of the weekly *Pourquoi Pas?*, showing Ensor as seen by the caricaturist Ochs.

52 *The Entry of Christ into Brussels* 1888. Collection Louis Franck, London (held in trust at the Musée des Beaux-Arts, Antwerp). This is the largest canvas Ensor ever painted (101½ x 169¾ in., 2.58 x 4.31 m) and the first that depends as much on the inventive qualities of the mask as on realistic depiction. According to W. Vanbeselaere, 'Here the expressive value of colour ... already anticipates the Expressionists' renovation of forms and colours.'

53 *The Entry of Christ into Brussels* 1888 (detail)

54 *Children Dressing* 1886. Collection Cleomir Jussiant, Antwerp. The main subject of this painting, the last of his series of

domestic interiors in Ostend, is a study of light. 'It is one of his most perfect canvases,' writes André de Ridder (*Ensor*, 1930), 'with its variegated and speckled surface in which the colour melts and flows to form broken lines, clashing zigzags, with incomparably fluid vibrations enveloping and blurring, with patches of silver and pink shapes that are merely sketched in, broken yet firm lines, anything that can recall a feeling of solid texture, the weight of bodies and objects.'

55 *Henri de Groux at the Billiard Table* 1907. This anecdotal drawing in coloured crayons recorded a special occasion and shows Ensor's liking for caricatures. According to a handwritten note it depicts the Belgian Symbolist painter Henri de Groux playing billiards in the Kursaal at Ostend. De Groux (1867-1930) had settled in Paris and a painting of his called *Ravaged Christ* had created a sensation in 1891; we should not forget that Ensor's *The Entry of Christ into Brussels* dated from 1888.

56 *The Antique-dealer* 1902. Collection Desprechine, Saint-Denis-Westrem, Belgium. The composition of this 'portrait' should be compared with that of the portrait of Eugène Demolder (plate 13). It is also notable for the very detailed reproduction of the antique paintings.

57 *Boats Stranded on the Beach* 1888, etching.

58 *Sick Tramp Trying to Get Warm* 1895, etching.

59 *Roman Triumph* 1889, etching and drypoint.

60 *Death Pursuing a Flock of People* 1896, etching.

61 *The Gendarmes* 1888. Musée des Beaux-Arts, Ostend.

62 *Portrait of Ernest Rousseau* 1887, drypoint.

63 *The Entry of Christ into Brussels* 1898, etching and drypoint.

64 *The Cathedral* 1886, etching.

65 *Christ Mocked (Jesus Shown to the Populace)* 1886, etching and drypoint.

66 *Hop-Frog's Revenge* 1898, etching and drypoint.

67 *Descent of Christ into Hell* 1895, etching and drypoint.

68 *Battle of the Golden Spurs* 1895, etching.

69 *Pond with Poplars* 1889, etching and drypoint.

71 *Panoramic View of Mariakerke* 1887, etching.

70 *The Beach at La Panne* 1904, etching.

72 *Christ in Triumph Surrounded by Masks and Demons* 1895, etching.

73 *The Judges* 1891.

74 *The Large Docks at Ostend* 1888, etching and drypoint.

75 *Christ Calming the Storm* 1886, etching and drypoint.

76 *The Skaters* 1889, etching.

77 *View of Nieuport (The Channel at Nieuert)* 1888, etching.

78 *My Portrait in 1960* 1888.

79 *Combat of Demons* 1888.

80 *The Orchard.*

81 *Demons Tormenting Me* 1895, etching.

82 *Devils on their Way to the Sabbath* 1887.

83 *Sorcerers caught in a Squall (The Winds)* 1888, etching.

84 *Silhouettes of Passers-by.*

85 *Envy* (one plate in the sequence called 'The Seven Deadly Sins', preface Eugène Demolder) 1904, etching.

86 *In the Street.*

87 *The Street.*

88 *Strange Masks* 1891. Musée d'Art Moderne, Brussels. The technical vigour of this painting, the delicate luminosity and the sharpness of the draughtsmanship are all remarkable.

89 *Windmill at Mariakerke (In the Dunes at Mariakerke)* 1889.

90 Signed and dated drawing in coloured crayons inspired by the Germans' arrival in Ostend in 1940. Collection Jean Milo, Brussels.

91 *Ensor and General Leman talking about Painting* 1890. Collection Marcel Mabille, Brussels.

92 *The Remorse of the Corsican Ogre* 1891. Collection Marcel Mabille, Brussels.

93 *Intrigue* 1890. Musée Royal des Beaux-Arts, Antwerp. This is one of the masterpieces of Ensor's 'great period', when he was painting masks. 'The twenty masks arranged to form a carnival scene, each with a completely different expression, embody man's various moods, his virtues and his vices, the most representative human expressions... They take part in a strange, hallucinatory double life, part man, part puppet.' André de Ridder)

94 *Village Fair with Black Puddings* 1901. Collection Madame Seewen, Ostend. Another very accomplished painting, full of the fine spirit of Ensor.

95 *The Animal Musicians (The Terrible Musicians)* 1891. Collection Baron Charles Janssen, La Hulpe.

96 *Still-life with Peaches c.* 1895.

97 *Skeletons Trying to get Warm* 1889.

98 *Studio Props (Props for the Beaux-Arts* or *Still-life with Anatomical Model)* 1889. Collection Roland Leten, Ghent.

99 *Old Woman with Masks (Bouquet d'Artifice)* 1889. Collection Roland Leten, Ghent.

100 *Masks Fighting over a Hanged Man* 1891. Musée Royal des Beaux-Arts, Antwerp. The attention to detail and the colour contrasts do not interfere with the pictorial unity of the overall composition.

101 *Melancholy Fishwives* 1892. Musée Royal des Beaux-Arts, Antwerp. The unexpected intrusion of three skulls does not interfere with the brilliant realism of observation and execution in this painting.

102 *Set for the ballet 'La Gamme d'Amour'* 1912. Ensor Museum, Ostend. Ensor was a music-lover and played the harmonium very pleasantly. He had composed the score for a short ballet called *La Gamme d'Amour,* for which he also designed the set and costumes. This is the set for the second scene.

103` *My Favourite Room* 1892. Museum of Art, Tel Aviv.

104 *Figures Looking at a Poster for 'La Gamme d'Amour'* 1895-1900. Collection Bénédict Goldschmidt, Brussels. This composition is a faithful copy of a detail from the top right- hand corner of *The Entry of Christ,* showing mountebanks performing on a fairground stage. But the pictorial quality is higher than in the other canvases he painted in this last period.

105 *Masks and Death* 1897. Musée des Beaux-Arts, Liège. We can sense that Ensor's powers were already declining by this time. His touch is hesitant and his earlier inspiration has given way to repetitions of earlier themes.

106 *Self-portrait with Masks* 1899. Collection C. Jussiant, Antwerp. Ensor has returned to the theme of *Old Woman with Masks,* but here the juxtaposition of heads seems commonplace because of the heavy-handed treatment.

107 Baron Ensor's coat of arms, designed by L. Diekmann. The motto runs: *Pro Luce Nobilis Sum.*

108 *The Dangerous Cooks* 1896. Collection Roland Leten, Ghent. This is one of the small caricatures that Ensor enjoyed to settle his differences with some of his contemporaries; some of his earlier engravings were executed in the same spirit.

109 Bust of James Ensor by Rik Wouters, bronze. Collection Julienne Boogaerts, Brussels. Ensor rejected this bust in favour of a poor marble effigy by an academic sculptor.

110 Ensor seated at the piano surrounded by his own paintings. (Photo: Antony, Ostend). Note that the still-life arranged on the table is the same as the subject of the painting below.

111 Ensor reading the newspaper with his manservant Auguste Van Yper.

112 Ensor playing the harmonium with *The Entry of Christ* in the background. (Photo: Antony, Ostend)

113 Ensor playing the harmonium. (Photo: Antony, Ostend)

155

Index